NO SLEEP TIL BROOKLYN

TABLE OF CONTENTS

is it Stock or Assignment ?

IPNSTOCK.COM
INDEPENDENT PHOTOGRAPHY NETWORK

Portal to a network of vast collections of stock images, providing creatives easy access to new work every day.

PhotoServe.com

Most up-to-date visual database of the world's best assignment photographers, rising stars and trends.

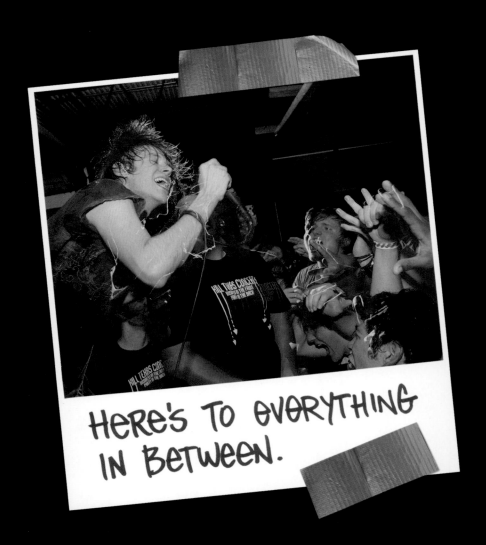

anthem

KNOW NOW

FEATURING:
MUSIC, FASHION, ART, FILM,
DESIGN, MEDIA, CULTURE

www.anthem-magazine.com

photograph

July/August 2006 $5

©Vincent Cianni, *Mike Doing A For Side Torque Soul, P.S. 84*, 1997 (detail). Courtesy Museum of the City of New York

photograph the bi-monthly USA guide to exhibitions, private dealers, auctions, events, resources, news and more. | A one-year subscription costs $35 US, $40 Canada, $70 all other international. Payment by check in US funds on a US bank or American Express, MasterCard, Visa. **photograph** 64 West 89th Street, New York, New York 10024 tel 212/787-0401 email photograph@bway.net | Visit us online at our website **www.photography-guide.com** for the latest information and hundreds of links, plus where to find the works of more than 1,500 artists.

THE MAGAZINE THAT READS LIKE A BOOK.

Providing comprehensive musical retrospectives since 2001.

▶ waxpoetics™
HIP-HOP, JAZZ, FUNK, & SOUL
waxpoetics.com

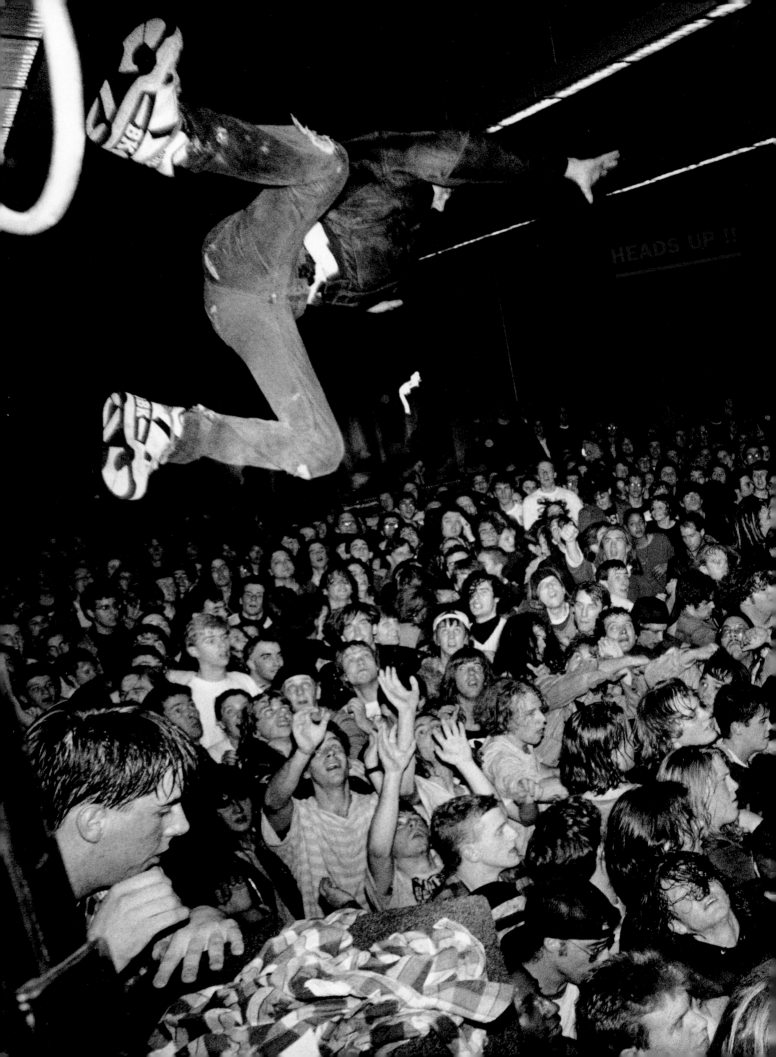

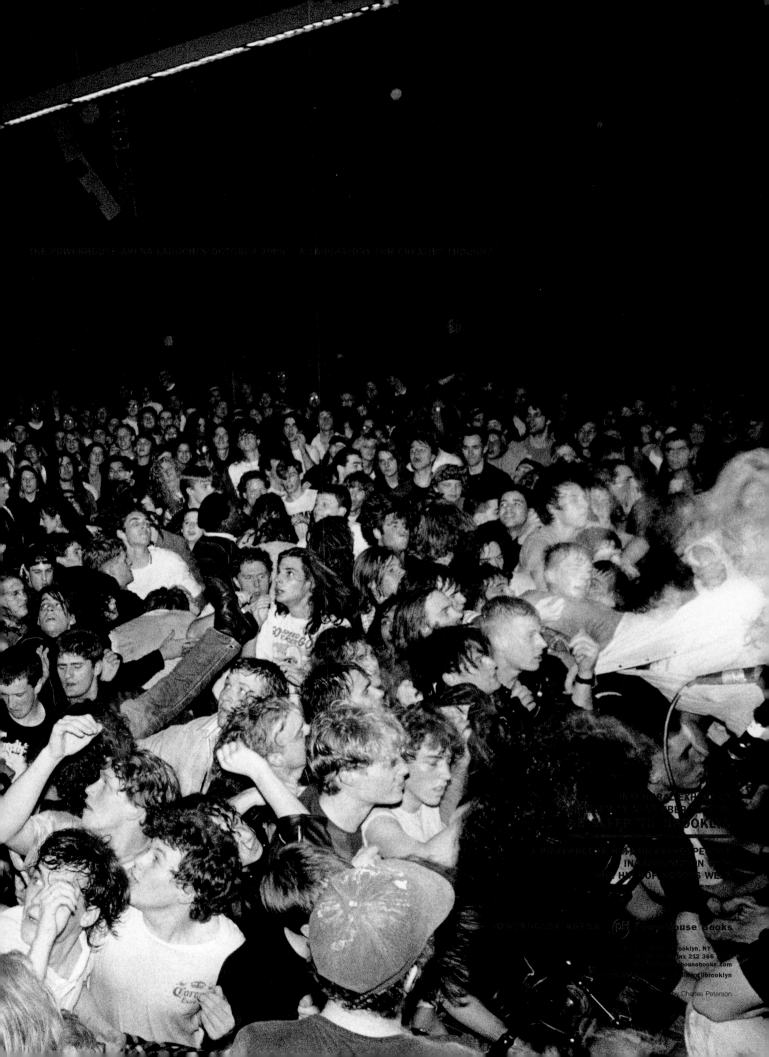

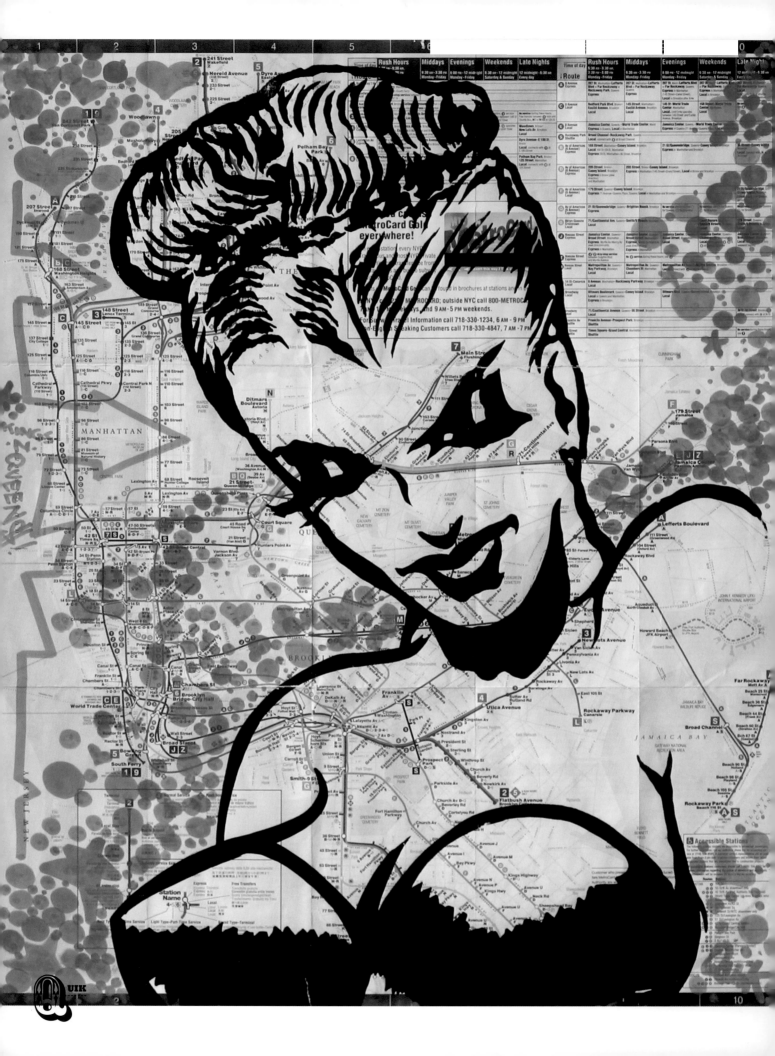

I grew up on the wrong side of the Bronx…

In the summer of 1978, my family moved from a small town on a lake outside Boston to a small neighborhood outside Manhattan on the Hudson River. Riverdale. A secluded enclave of spacious post-war apartment buildings nestled on hills dotted with countless parks. Best known for its private schools and higher-priced homes near Wave Hill, the population was primarily Jewish middle class with a smattering of Japanese families who moved in when fathers were transferred to the New York office. While there were a couple of abandoned lots and the occasional workers' strike, it was a haven in what was otherwise the city's most infamous borough.

Though later indicted for corruption, then-Bronx borough president Stanley Simon allocated funds to weekly Wednesday night summer concerts in neighborhoods populated by Democratic voting blocks. I remember reading the banner that hung outside the park (conveniently located opposite our apartment building) wondering why we didn't get salsa or merengue sessions. Instead we had bar mitzvah cover bands playing *Abracadabra*, *Upside Down*, and other AM pop radio classics. Thing is, back then, I didn't know any better; I loved those concerts. I'd show up rocking hand-me-down 70s synthetics, dancing with my friends, giggling at the grandmas who clasped hands, swaying in half-time to the beat.

It was only decades later, when reading Charlie Ahearn and Jim Fricke's astounding oral history *Yes Yes Y'all* that I realized how close I had been to the center of things. Not that my parents would have let me go to a Zulu Nation Throwdown. Err, no. But to know that it was happening only miles from me and the old ladies on quite possibly the same evening still astounds me. So near, yet so damn far.

Around the time of the concerts, another unexpected phenomenon occurred—Eddie Martinez and Jordan Milan (a couple of charismatic Puerto Rican boys in our class) showed up in airbrushed sweatshirts, straight-leg, pin-stripe Lee jeans, and shell-top adidas. At lunchtime in the cafeteria, they would jump into the middle of the crowd (that had mastered the casual side-to-side step) and start breakin' to *Another One Bites the Dust*, *Maneater*, and other 45s some teacher had thoughtfully provided. Shit was madness. They had backspins, windmills, ill freezes. The adidas would fly off their feet and rolled up sweat socks would sail across the room while we stood in awe, trying to figure out how they had these moves when the best we could do was spin a couple of hula hoops.

Sometime around fifth or sixth grade, I started going downtown—to Canal Jeans, specifically, to buy oversized sweatshirts, lycra leggings, and slip-on skippies in obscene colors to match the checkerboard pins I was snatching from the plastic bucket on the counter by the cashier. Lord have mercy on my outfits. I remember some of those looks: purple plastic peace symbol earrings; a turquoise fishtail skirt with a striped shirt and a wide belt; a white denim vest; fuschia pumps; maybe all of these at the same time. I don't think I was "hip hop" so much as

"don't stop," but at the time I was pretty damn sure I was Lisa Bonet on *The Cosby Show*.

See that was the thing: style is where you find it, and the 80s had it in spades. And when I got to junior high I saw it everywhere. JHS 141 had kids from all over Kingsbridge coming through in the best of the Boogie Down circa 86: shearlings and two-finger rings, bubblegum stretch jeans in pink acid wash, fake Gucci sweatshirts in white or navy, DAs with blonde tails (on girls too!)….I remember sitting in art class, opposite Kelly, a statuesque, light-skinned black girl, talking about LL Cool J. She was wearing pink (like Molly Ringwald that year), looking at where I had written INXS on my notebook. "What's 'inks'?" she asked, and it was at that point I thought about expanding my repertoire beyond WLIR. I was going through a New Wave stage; maybe it was the synthesizers and the wine coolers. But I still had a love for hip hop—so by the time I hit high school it was on. And though I had finally left the Bronx, it never left me.

It is unlike any other borough in the city. It is unlike the borough it once was. It is the birthplace of hip hop—the home of Kool DJ Herc, Afrika Bambaataa, Grand Wizard Theodore, the Cold Crush Brothers, of b-boys, MCs, DJs, and graff writers whose music, moves, and style would create an art form that swept the world like a couple of flares into a windmill or a DONDI train coming down the tracks. With the support of photographers, filmmakers, and personalities like Martha Cooper, Henry Chalfant, Charlie Ahearn, Patti Astor, and Fab 5 Freddy, my generation has been so profoundly influenced by hip hop that we have come to see it as more than an art form. It is a way of life.

Growing up in the 80s, I read *Interview* religiously. Little did I know that, one day, the artists and writers whose work and ideas inspired and influenced me would one day become my colleagues. I have always maintained a theory that New York City is made up of concentric circles, bringing together the worlds of art, architecture, design, fashion, beauty, music, film, theater, dance, and literature, sparking cultural phenomena to take root and flourish.

It is by virtue of working for powerHouse Books that I now stand at the center of so many circles that I must keep from getting dizzy by staying focused. In the strangest way, my life has begun to reference itself, and it is with great humility and deep appreciation that I realize that I have come to the right side of the Bronx, by way of Brooklyn—37 Main Street to be exact. It is here, in this laboratory for creative thought, that *No Sleep 'til Brooklyn* was born. Both the premier issue of *powerHouse magazine* and the inaugural exhibition at The powerHouse Arena, *No Sleep 'til Brooklyn* is a 30-year retrospective of hip hop culture: documenting its humble beginnings in the South Bronx through its glorious rise to global domination. But this is by no means a story of celebrity, fame, and mass market names. It is the story of the people and of the streets, a tribute to the founders, a salute to the innovators, and a nod to the next generation who will one day reign.

Welcome.
—Miss Rosen

powerHouse magazine

Issue 1

Publisher: Daniel Power
Associate Publisher & Production Director: Craig Cohen
Editor: Miss Rosen
Art Director: Mine Suda
Copy Editor: Nicholas Weist

Contributing Artists:
Bob Adelman, Charlie Ahearn, Janette Beckman, Peter Beste,
BL .ONE, Boogie, Martha Camarillo, Henry Chalfant, Vincent
Cianni, Claw Money, Martha Cooper, DAZE, DG, DR.REVOLT,
Delphine Fawundu-Buford, Carol Friedman, Hamburger Eye,
JA, JERMS, Lisa Kahane, LADY PINK, Helen Levitt, Maripol,
NATO, Charles Peterson, Mark Peterson, Doug Pray, QUIK,
Ricky Powell, Carlos "MARE 139" Rodriguez, Joseph
Rodríguez, Randy "KEL 1ST" Rodriguez, Thomas Roma, Q.
Sakamaki, Jamel Shabazz, SLASH, Peter Sutherland, TOOFL'
and Craig Wetherby.

Contributing Writers:
Patti Astor, Henry Chalfant, Ana "Rokafella" Garcia, MISS17
Chris Nieratko, Ricky Powell, Carlos "MARE 139" Rodriguez,
Joseph Rodríguez, Miss Rosen, and Jamel Shabazz.

For advertising inquiries please contact Miss Rosen
tel: 212 604 9074 x105, email: sara@powerhousebooks.com

For distribution inquiries please contact Wes Del Val
tel: 212 604 9074 x103, email: wes@powerhousebooks.com

powerHouse Magazine
37 Main Street, Brooklyn NY 11201
Tel: 212.604.9074
Fax: 212.366.5247
Email: magazine@powerhousebooks.com

ThepowerHouse magazine.com

Charlie Ahearn wrote and directed *Wild Style* (1982) and *Fear of Fiction* (2000). Ahearn coauthored *Yes Yes Y'all* (Da Capo Press, 2002) with Jim Fricke. His second book, *Wild Style: The Sampler* (Miss Rosen Editions/powerHouse Books), will be published in spring 2007. www.wildstylethemovie.com

Patti Astor, the founder of FUN Gallery, appeared in a dozen films, including *Wild Style*, *Rome '78*, *The Long Island Four*, *Snakewoman*, and *Underground U.S.A. FUN! The True Story of Patti Astor* (Miss Rosen Editions/powerHouse Books) will be published in conjunction with the documentary *Patti Astor's FUN Gallery*, and a feature with Roberts/David Films.

Janette Beckman has photographed countless album covers, including The Police's first three LPs. Her books include *RAP: Portraits and Lyrics of a Generation of Black Rockers* (St. Martin's Press, 1991) and *Made in the UK: The Music of Attitude 1977–1983* and *The Breaks: Kickin' It Old School 1982–1990* (powerHouse Books, 2005 and 2007). www.janettebeckman.com/jb.rocks

Brooklyn resident **Peter Beste** has been working on a photography book about the ghettos, black nightclubs, and lifestyles of the hustlers and rappers in his hometown of Houston, Texas. His work has appeared in *Spin*, *The Fader*, *American Photo*, *Vice*, *The Face*, *Dazed and Confused*, *XXL*, *Mass Appeal*, and many others. www.peterbeste.com

BL .ONE aka Johnny Walker Down with the notorious TMR CREW, WDD, VIC, NWC, and FTR from Queens back in the late 80s and 90s, BL .ONE is now better known for his music production as Johnny Walker, one half of Cold Heat Entertainment, with his partner Jak Danielz. www.myspace.com/jakdanielz

Boogie was born and raised in Belgade, Serbia, and now lives in Brooklyn, New York. His first book, *It's All Good* (Miss Rosen Editions/powerHouse Books) will be released in October 2006. www.artcoup.com

Martha Camarillo's work has appeared in *The New York Times*, *The Telegraph*, *Numero*, *Journal*, *i-D*, and many others. She is the author of *Remote Photos* (Editions Léo Scheer, 2005), a collaboration with artist Avena Gallagher, and her new book, *Fletcher Street*, will be published by powerHouse Books in fall 2006.

Henry Chalfant is a co-author of *Subway Art* (Holt Rinehart Winston, 1984) and *Spray Can Art* (Thames and Hudson, 1987). He also co-produced *Style Wars* (1984) and directed *Mambo to Hip Hop*, which will be broadcast on PBS in 2006. www.stylewars.com

Brooklyn resident **Vincent Cianni** is author of *We Skate Hardcore* (New York University Press/Center for Documentary Studies, 2004). Cianni's photographs have been exhibited at The Museum of the City of New York; Museum of Fine Arts, Houston; The Photographers' Gallery, London; and the George Eastman House, Rochester, NY, among others. www.vincentcianni.com

Claw Money founded graff crew PMS and the Claw Money clothing line. Star of *Infamy*, fashion director of Swindle, and vintage couture collector par excellence, Claw's first book, *Bombshell: The Life and Crimes of Claw Money* (Miss Rosen Editions/powerHouse Books) will be published in spring 2007. www.clawmoney.com

Martha Cooper is a co-author of *Subway Art* (Holt Rinehart Winston, 1984), *We B*Girlz* and *New Yory State of Mind* (Miss Rosen Editions/powerHouse Books, 2005 and 2007), *Hip Hop Files: Photographs 1979-1984* and *Street Play* (From Here To Fame, 2004 and 2006), and *R.I.P.: Memorial Wall Art* (Thames & Hudson, 1994). www.bgirlz.com

DAZE aka Chris Ellis, has been a pivotal figure in the history of graffiti art, helping break the medium into the New York gallery scene and beyond. His work is in the permanent collection of the Museum of Modern Art and The Brooklyn Museum, New York; Groningen Museum, and The Chase Manhattan Collection. www.dazeworld.com

DG NWC VIC FTR WDD MTA was born and raised in Queens, NY. DG is a piece artist and serious street bomber: hitting trains, freights, highways, and more.

Brooklyn resident **Martin Dixon** counts among his clients The Ford Foundation, The John D. and Catherine T. MacArthur Foundation, Oxford Health, Towers Perrin, Guinness, Lipman Hearne, and a host of record labels and popular magazines. Dixon is the author of *Brooklyn Kings: New York City's Black Bikers* (powerHouse Books, 2000).

DR.REVOLT, an original member of The Rolling Thunder Writers, created the classic *YO! MTV Raps* logo and did a tour of duty in Baltimore where he single-handedly kick-started a graff scene that still feels his influence. http://www.nytrash.com/Revolt.html

Brooklyn resident **Delphine Fawundu-Buford**'s photographs have been published in *Unbelievable: The Life, Death, and Afterlife of the Notorious B.I.G* (Vibe Books, 2004), *Black: A Celebration of Culture* (Hylas Publishing, 2004), *Enduring Visions* (Davis Publications, 2001), and *Reflections in Black* (Norton, 2000). www.delphinefawundu.com

Carol Friedman is a portrait photographer and record company creative director (Elektra Entertainment and Motown). The images published here are from her personal archives and have never before been published. Friedman is the author of *Baby Cat Nicky 123* and *Nicky the Jazz Cat* (powerHouse kids, 2005) www.carolfriedman.com www.nickythejazzcat.com

Ana "Rokafella" Garcia—dancer, singer, actor, and writer—is the cofounder of Full Circle Productions, a hip hop artist collective that has performs around the world. Rokafella has worked with Will Smith, Mariah Carey, Whitney Houston, and Tito Puente to name just a few. www.fullcirclesoul.com

Hamburger Eyes magazine, published by Burgerworld Media, San Francisco, features the work of photographers Stefan Simikich, Ray Potes, David Potes, Ted Pushinsky, Boogie, and Jason Roberts Dobrin, among countless others. They will publish their first book, *Burgerworld: Inside Hamburger Eyes* (Miss Rosen Editions/powerHouse Books) in fall 2007. www.hamburgereyes.com

JA XTC has hit spots in NY, LA, and Europe, and is notorious for writing in the most dangerous places.

JERMS FTR WDD 123 is better known as DJ JS -1, DJ for Rahzel & The Rock Steady Crew. JERMS has done numerous pieces in his day with partner SLASH, and has been touring the world for six years with Rahzel. www.myspace.com/djjs1groundoriginal

Lisa Kahane has worked as a photographer since 1975, specializing in documentary work and portraiture. Her work is in private collections as well as the permanent collection of the New York Public Library and the Fales Library at New York University, New York, and the Library of Congress, Washington, D.C. She teaches photography to kids at risk. www.lisakahane.com

continued...

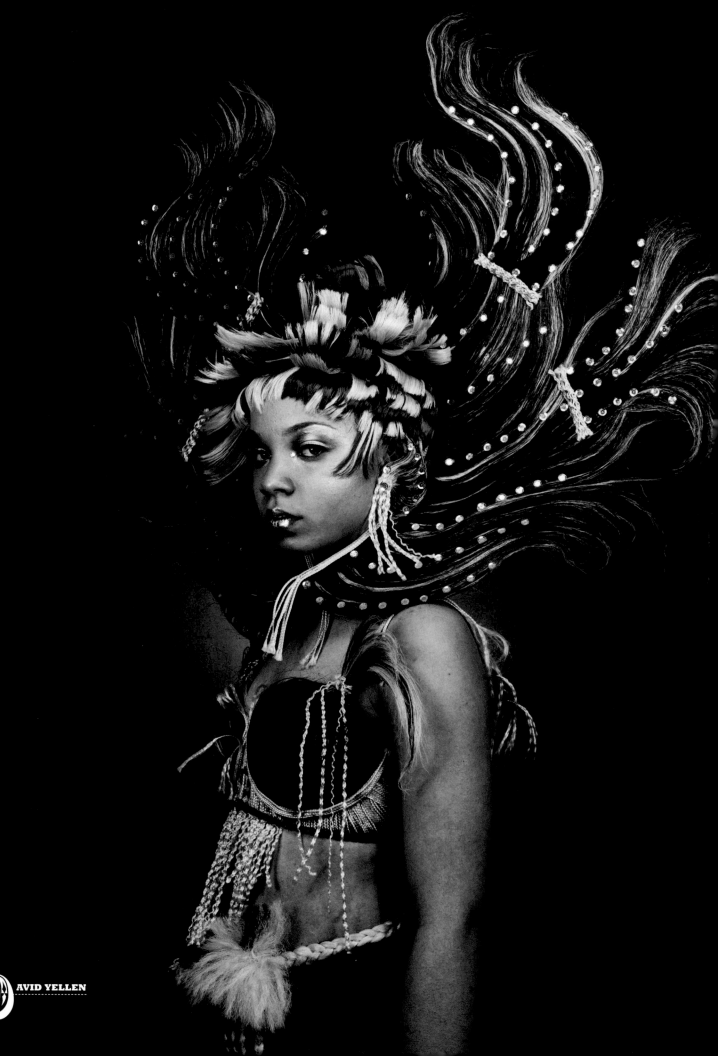

LADY PINK started writing graffiti at the age of 15, painted trains from 1979 to 1985, and co-starred in *Wild Style*. Her work is in the collections of the Whitney Museum of American Art, The Metropolitan Museum of Art, the Brooklyn Museum, and the Museum of the City of New York, among others.

Helen Levitt has had retrospective exhibitions at The Museum of Fine Arts, Boston; the San Francisco Museum of Modern Art; The Metropolitan Museum of Art, and the International Center of Photography, New York. She is the author of several books, including *Crosstown, Here and There,* and *Slide Show* (powerHouse Books, 2001, 2004, and 2006).

MISS 17 is a New York–based wild maniac who writes on everything.

NATO's daredevil graffiti career came to a halt in September 2000 when he was arrested and convicted of felony graffiti. As a result he rechanneled most of his artistic energy into showcasing in exhibitions at the Martinez Gallery. NATO is co-authoring *Graffiti NYC* (Prestel, 2006) with Hugo Martinez.

Chris Nieratko has been handed such posh jobs as editor of *Big Brother*, columnist for *Vice* and *Bizarre* (UK), and regular contributor to *Paper* and *Vibe*. He runs a production company (Freshkills.net) and a skateshop (NJSkateshop.com). *Skinema* (Vice Books, distributed by powerHouse), a collection porn reviews, will be released in spring 2007.

Charles Peterson is best known for his documentation of the grunge scene, culminating in the critically acclaimed photo book *Touch Me I'm Sick* (powerHouse, 2003). His previous books include *Screaming Life* (Harper Collins 1995), and *Pearl Jam Place/Date* (Universe, 1997). www.charlespeterson.net

The author of *Acts of Charity* (powerHouse Books, 2004), **Mark Peterson**'s work has appeared in *New York* magazine, *The New York Times Magazine*, *Geo*, and *Esquire*, among many others. He lives in New Jersey with his wife Greta Pratt and their two children, Axel and Rose.

QUIK's work, which includes graffiti art and paintings and focuses on social injustice and racial discrimination, became recognized by the art world in the 1980s. He has also worked as a director's assistant, production coordinator, set designer, and actor in avant-garde theater. www.quiknyc.com

Ricky Powell is the author of *Public Access: Ricky Powell Photographs 1985–2005* (Miss Rosen Editions/powerHouse Books, 2005), *Frozade Moments* (Eyejammie.com, 2005), and *Oh Snap!: The Rap Photography of Ricky Powell* and *The Rickford Files: Classic New York Photographs* (St. Martin's, 1998 and 1999). www.rickypowell.com

Doug Pray's documentary films include *Scratch, Hype!,* and *Infamy*. Other projects nearing completion include *Big Rig*, about American truck drivers, and *Supernatural*, a portrait of the legendary Paskowitz surfing family. Pray also edited *American Pimp* for directors Allen and Albert Hughes. www.infamythemovie.com

Carlos "MARE 139" Rodriguez, a former graffiti writer, is now a sculptor. Recipient of the 2006 Webby Award for *Style Wars*, he also designed the Annual BET Award sculpture. Rodriguez is currently working with Robert DeNiro on his current directorial effort, *The Good Shepard*. www.mare139.com, www.stylewars.com

Joseph Rodríguez has been awarded Pictures of the Year by the National Press Photographers Association in 1990, 1992, 1996, and 2002. His previous books include *Flesh Life: Sex in Mexico, Juvenile,* and *East Side Stories: Gang Life in East L.A.* (powerHouse Books, 2006, 2003, and 1998), among others. www.josephrodriguez.com

Randy "KEL 1ST" Rodriguez, a former graffiti writer, began by designing custom jewelry for Debi Mazar and Madonna; his clients currently include Busta Rhymes and Kelis. KEL produced and designed the *The Year of The Sneaker* module for the Council of Fashion Designers Awards. www.kel1st.com

Brooklyn native **Thomas Roma** is director of photography at Columbia University, two-time recipient of the Guggenheim fellowship, author of nine photography books, and has had solo exhibitions at the Museum of Modern Art and the International Center of Photography.

Miss Rosen is publicity director of powerHouse Books, publisher of Miss Rosen Editions, and contributing writer for *Swindle, Whitewall,* and *Staf* magazines. Her production credits include *We B*Girlz: A 25th Anniversary Breakin' Event* at Lincoln Center Out of Doors, and the graffiti episode of Donald Trump's NBC show *The Apprentice*. www.onthetownwithmissrosen.blogspot.com

Q. Sakamaki photographs war zones such as Afghanistan, Iraq, Palestine, Liberia, Bosnia, and Kosovo. His photographs have been published in *Time, Life, Stern,* and *L'Espresso*, and in three books. Sakamaki has contributed to the film *Liberia: An Uncivil War*, directed by Jonathan Stack. www.qsakamaki.com

Jamel Shabazz is the author of *Back in the Days, The Last Sunday in June,* and *A Time Before Crack* (powerHouse Books, 2001, 2003, and 2005). His photographs have been exhibited at the Brooklyn Museum and the Bronx Museum of the Arts, New York, as well as in galleries around the world. www.jamelshabazz.com

SLASH FTR NWC MTA WDD is a graffiti artist.

Peter Sutherland, photographer and filmmaker, is the author of *Autograf: New York City's Graffiti Writers* and *Pedal* (powerHouse Books, 2004 and 2006). He has shown his work at Bape, Tokyo; colette, Paris; The powerHouse Gallery, New York; and CC room, Berlin; among others. www.petersutherland.net

TOOFLY applies her style to fashion accessories, stationary labels, limited edition t-shirts, and paper goods. Her street art is currently on display at the Graffiti Hall of Fame, Hunts Point in the Bronx, and various walls throughout Williamsburg, Brooklyn. www.tooflydesign.com

A self-taught photographer, Brooklyn native **Craig Wetherby**'s work has appeared in magazines such as *Spin, Rolling Stone, XXL, Vibe, Frank151, Swindle, Mass Appeal, The Fader, Stuff, Snowboard Canada,* and *Warp Japan* for over a decade. www.craigwetherby.com

David Yellen is the author of *Too Fast For Love* (powerHouse Books, 2004), which was exhibited at the Visionaire Gallery and The powerHouse Gallery, New York. His photographs have appeared in *The New York Times Magazine, Time, Spin, Rolling Stone, XXL, ESPN, Dutch, Nylon,* and *V*. His forthcoming book on Hair Wars will be published by powerHouse Books in fall 2007. www.davidyellen.com

FRESH GROUND BEEF $1.59 or LB. 2 LBS. for $3.00

FRESH PORK SHOULDER 99¢ LB.

FRESH WHOLE CHICKEN 99¢ LB.

FROZEN DUCKS $1.59 LB.

SALTE PIG'S TAIL

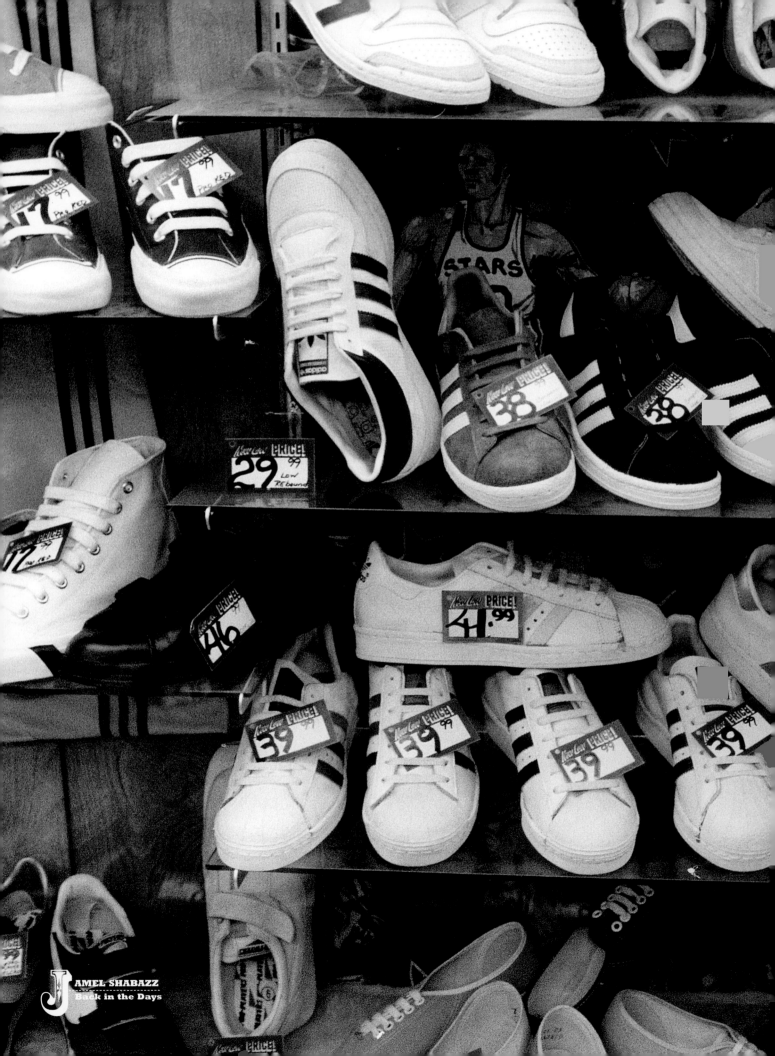

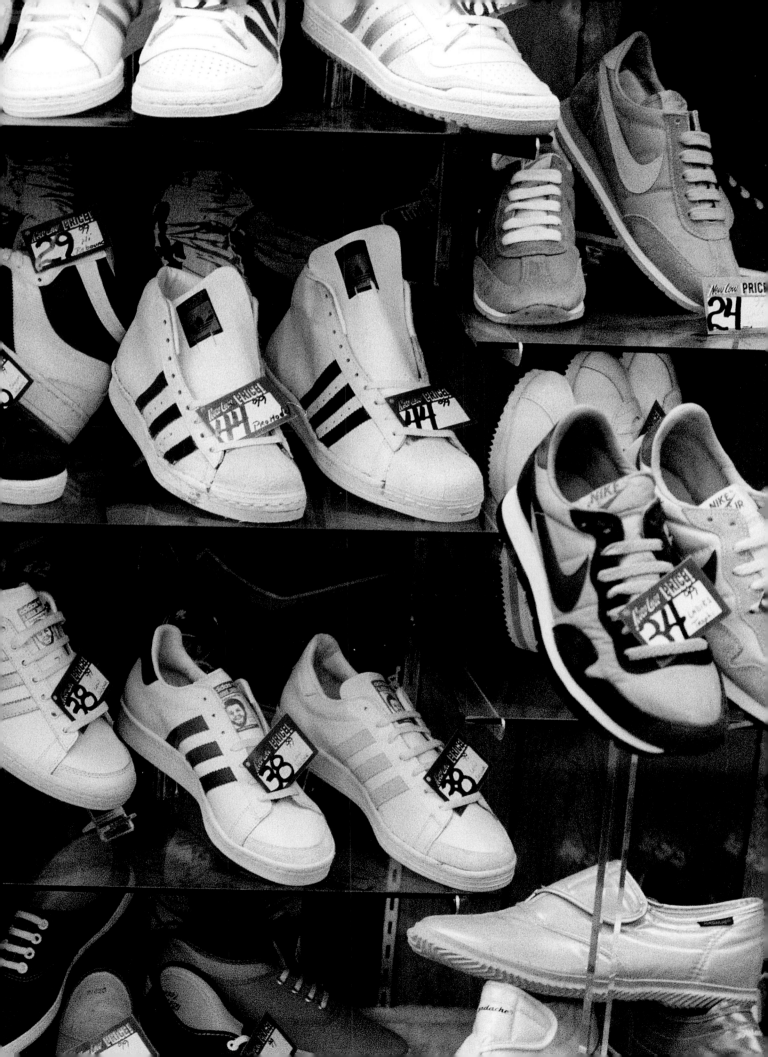

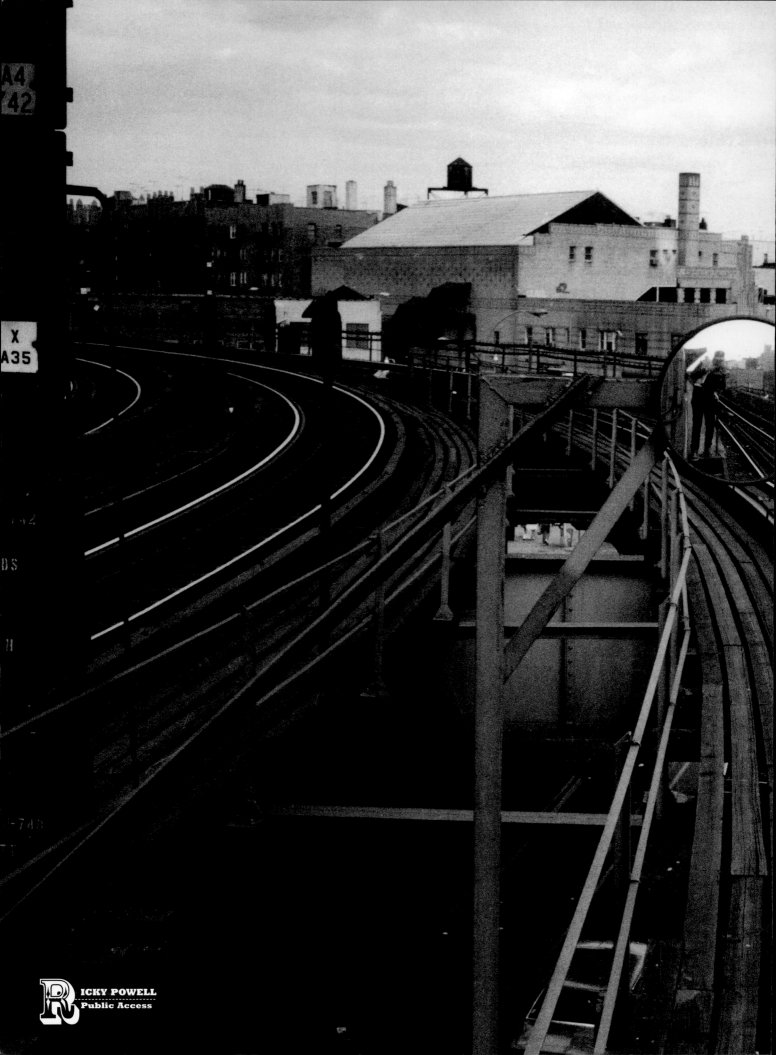

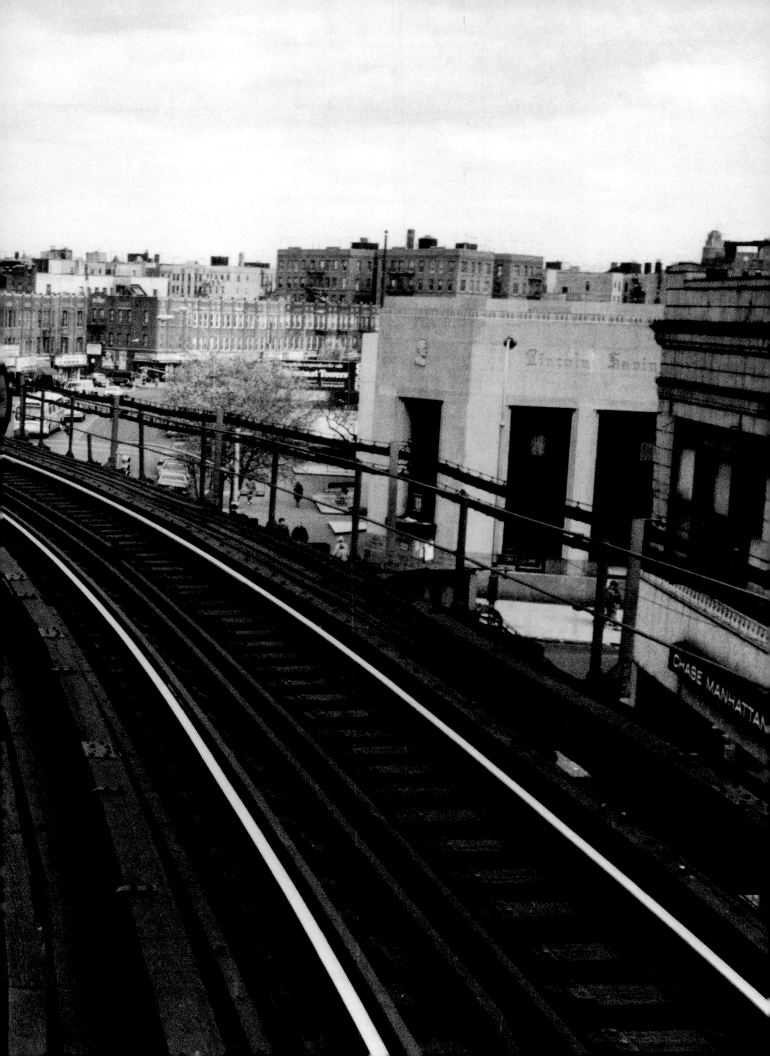

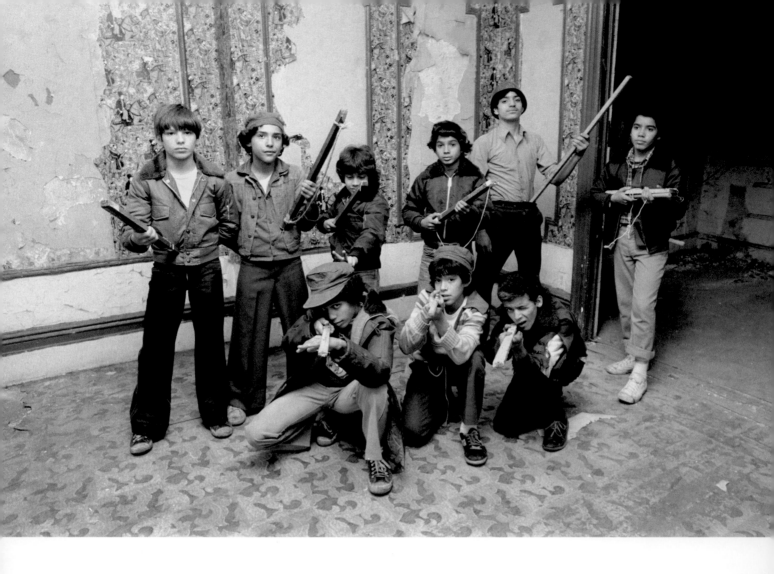

MARTHA COOPER TEXT BY **CARLOS "MARE 139" RODRIGUEZ**
Street Play

Bang Bang You're Dead

AK 47, Mack 10, UZI, Street Sweeper? Ask me that back then—I would have been like, "huh?" Playing cowboys, cops and robbers, or Mafiosi required real hardware, like a hammer, a stick with a nail and a rubber band, a broom, or sometimes—in my case—a zip gun. I bought my first zip gun for about $3 of laundry change, for which I received a medieval ass whipping from my mom. It was a small Derringer-style .22 caliber wrapped in black electrical tape.

Making guns was a relatively easy thing to do since all it required was a relatively good piece of wood, tape, metal tubing, a nail, and a strong rubber band. I've seen many variations of them, like a Tommy Gun or a .45 caliber, even a rifle. I even saw a kid who attached a 007 switch blade to the front of his rifle-style zip gun to make it look like a military-issue weapon. Thank God kids have forgotten about this crafty manufacturing. Can you imagine what our streets would look like—or better yet what the guns would look like?

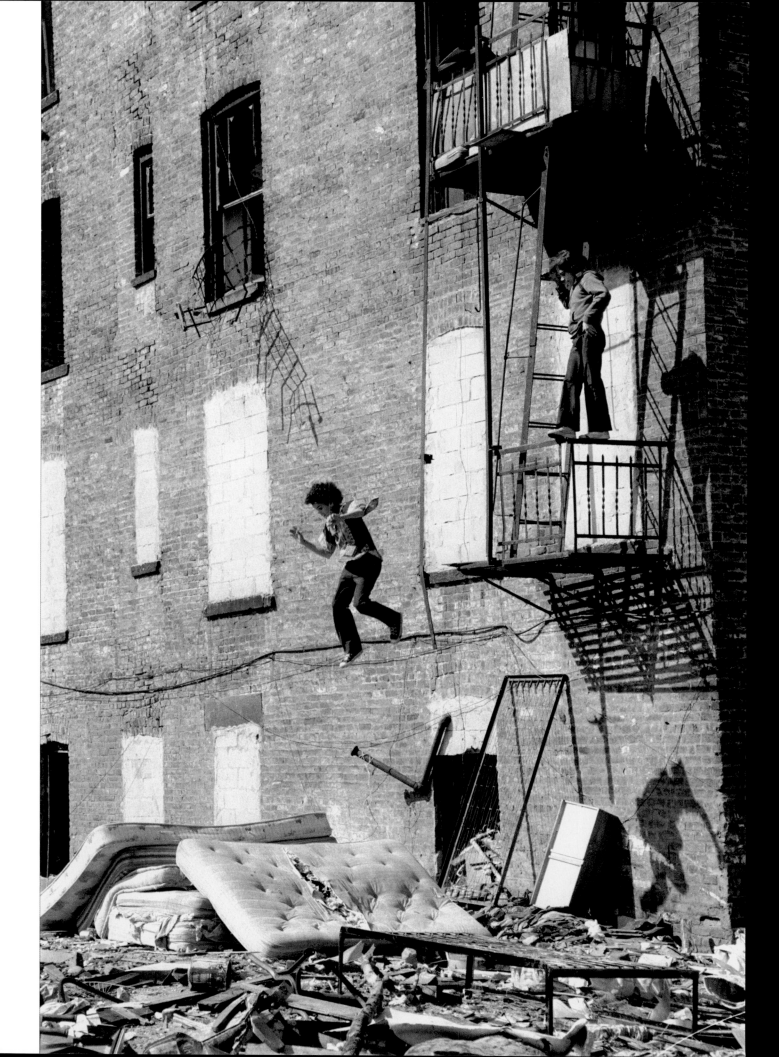

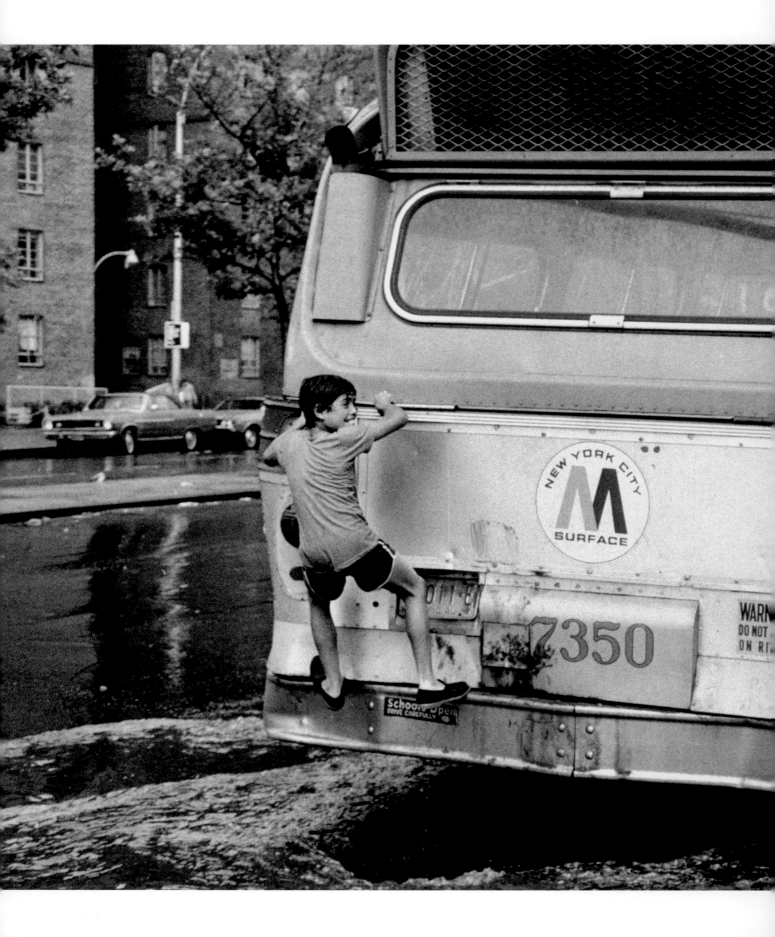

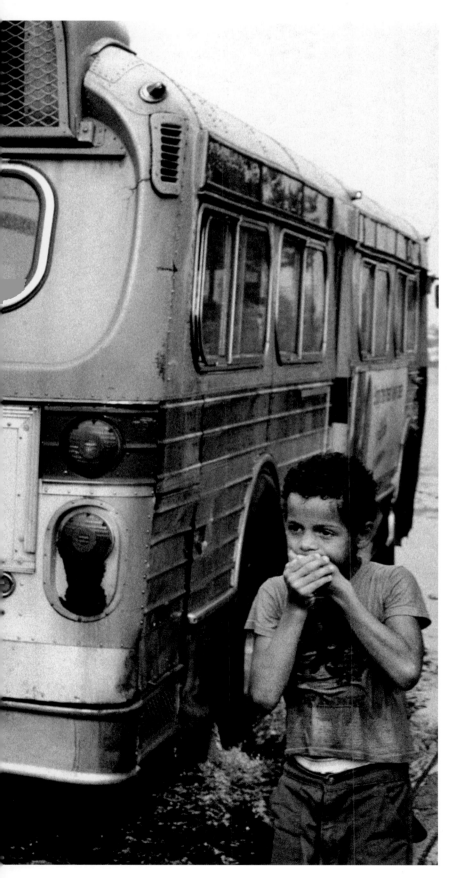

Fun in Motion

For kicks and practical reasons I used to hitch the back of city buses to get my tag and myself from point A to B. I learned early on that this mischief was also play, so hitching and tagging a bus served a dual purpose for me. We also used to bench (watch) buses as they rolled by to see who got their name or masterpiece on them. 7UP (Mitch77) was one of my favorites because he would fit his name perfectly on the side of the bus like an advertisement.

I was considered a toy in those days, so to make a name for myself I had to motion tag buses and moving trains, which were far more dangerous. Hopping in between train cars or hanging outside the last car was crazy, dumb shit now that I think about it! Fun is remembered as foolishness in hindsight, I suppose. ▣

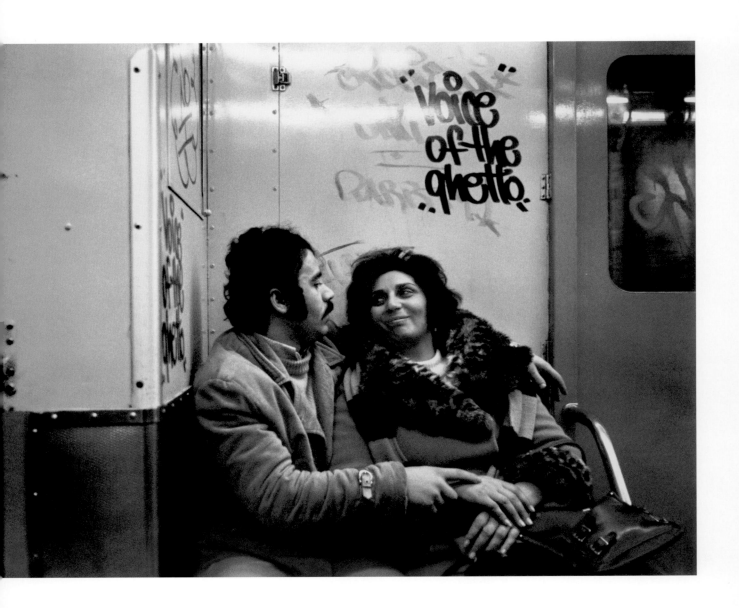

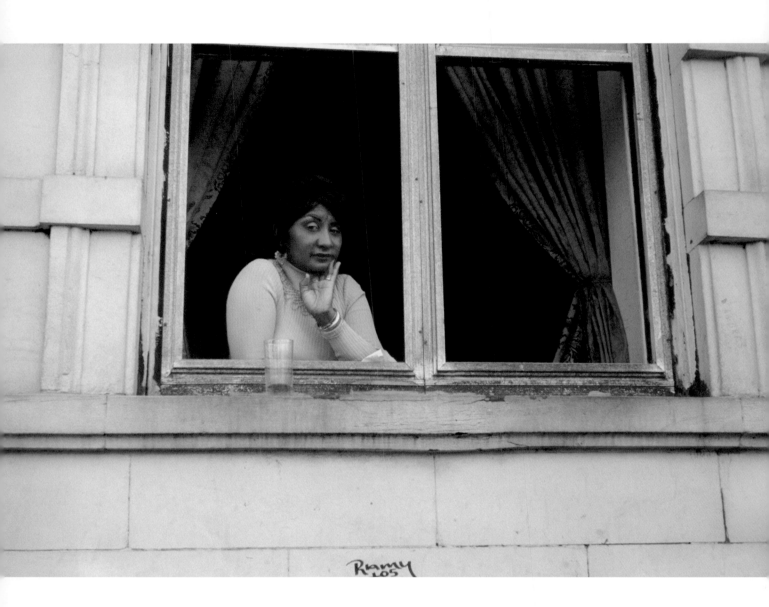

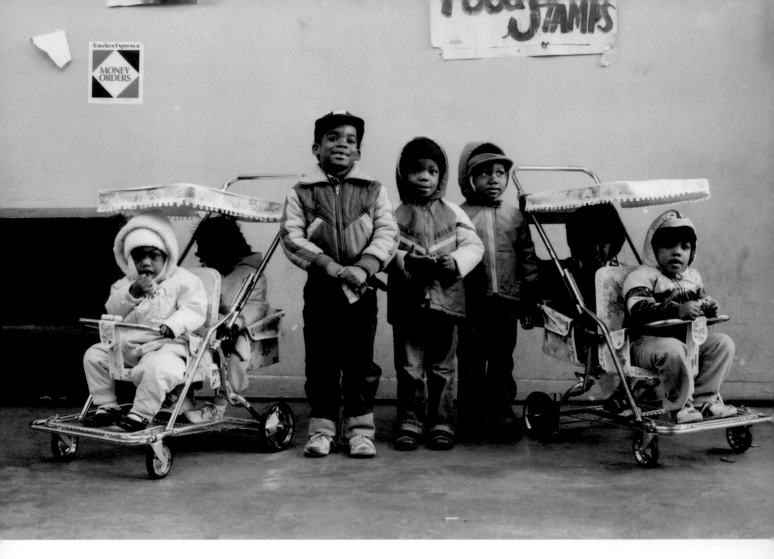

JAMEL SHABAZZ
A Time Before Crack

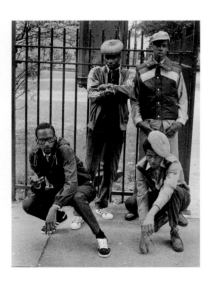

My generation represents those born between 1960 and 1970. Many of us have strong Southern roots. The majority of our parents migrated from the Carolinas, Alabama, Georgia, and Virginia to escape the Jim Crow laws of the 1920s through the 50s. Others in our circle were born from first-generation immigrants that came to America in the late 1950s from the Caribbean islands. Most of my peers came from two-parent households. Generations of our grandfathers, fathers, and uncles served in the military, in World War II and Korea.

In a number of families the men held government jobs while the women stayed home and nurtured the children. Both the family and the extended family looked out for one another. The saying "It takes a village to raise a child" formed a common practice.

We were taught morals and principles and given a foundation that would aid us in becoming productive citizens.

When crack made its debut in the mid-80s it created havoc throughout urban America, bringing with it death and despair. Crack was highly addictive and inexpensive. When smoked it reached the brain fast and created a feeling of euphoria in ten to 15 seconds.

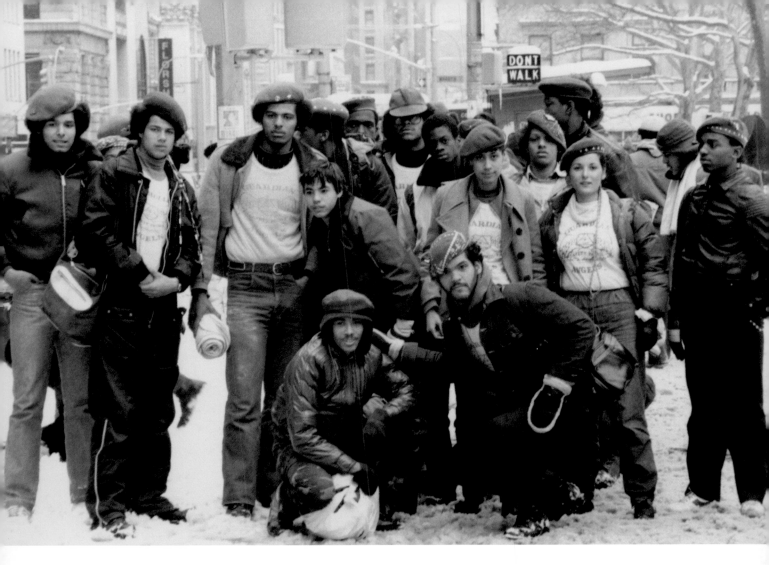

Thousands of women would become casualties of this new plague, often selling their bodies for little or nothing—so they could buy a "hit" of crack. A former victim once told me, "Crack makes slaves out of women and freaks out of men."

A major increase of child abuse and parental neglect, along with a rise in birth defects, came into play. Children swelled the foster care system and others were left in the care of their already burdened grandparents.

In June of 1985, the New York City Police Department had not yet made any arrests for crack offenses. In the first ten months of 1988, they made more than 19,000. The prison industry quickly became a booming enterprise. Under the strict Rockefeller drug laws, harsh and unfair punishments were issued to first-time drug offenders. A simple possession of crack cocaine charge was deemed a felony and could carry a five-year mandatory sentence.

Hospital emergency rooms were filled with scores of victims suffering from gunshot wounds inflicted by weapons of mass destruction. The funeral parlor industry flourished, servicing young men and women who had met their death prematurely.

Children were left without parents and suffered from post-traumatic stress disorder.

The effects of crack would linger on for generations to come.

My generation would sustain the highest rate of casualties from this monster. Sad to say, all of us have known someone who fell victim to its powerful jaws.

These photographs are part of a visual diary of the encounters I have had with young people throughout New York City, made between 1975 and 1984. What was most important to me was not so much getting the picture, but having a chance to communicate with them about life and their choices.

After taking a photograph, I would always make it a point to say to them these simple words: "Everything you do today will reflect upon your future." Then we would depart, oftentimes never seeing each other again.

This project has granted me the opportunity not only to preserve history, but to also give those who stood in front of my camera the chance to see themselves and their peers, in a time before crack.

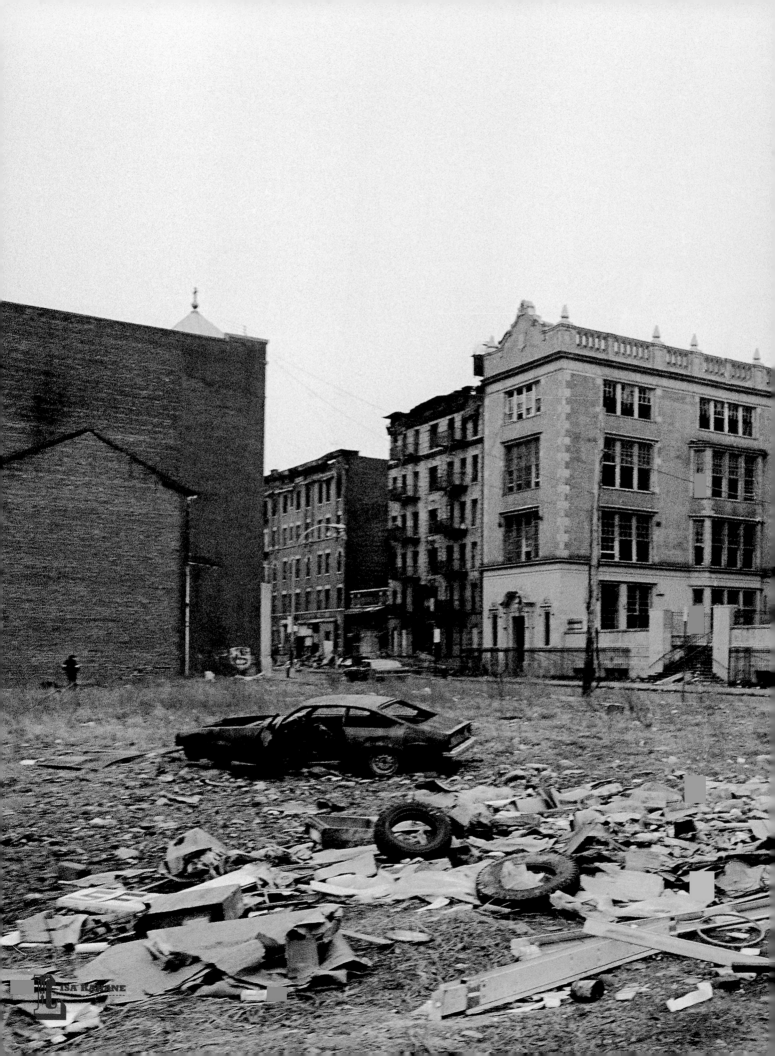

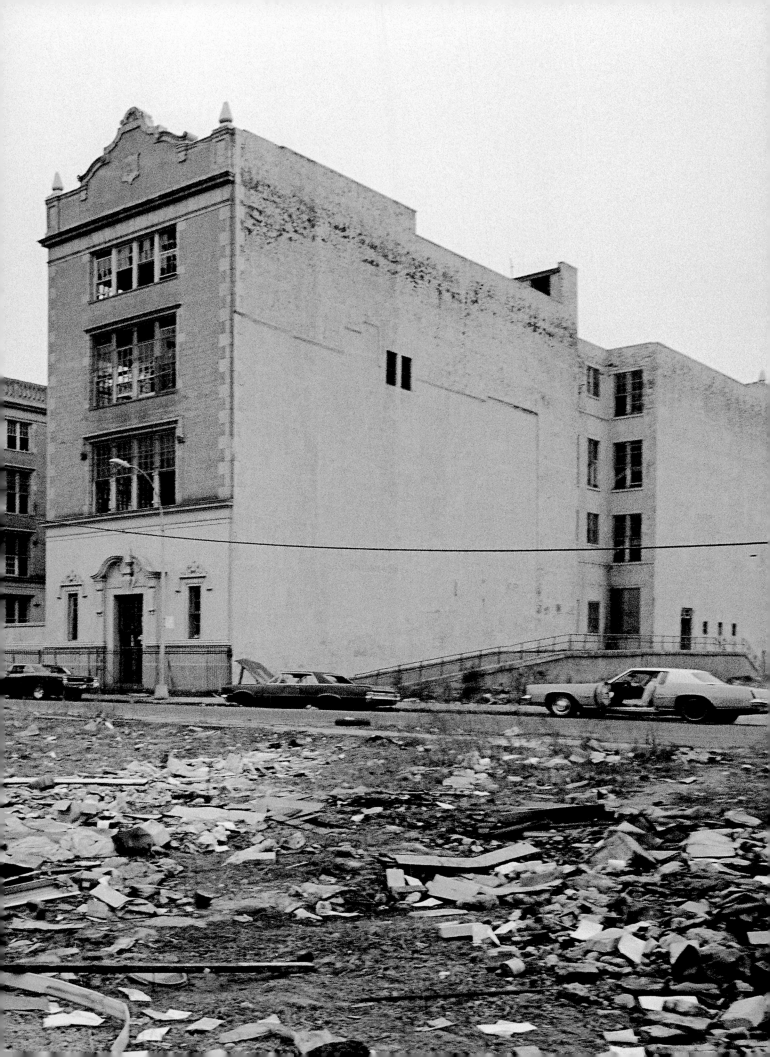

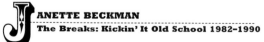

JANETTE BECKMAN
The Breaks: Kickin' It Old School 1982–1990

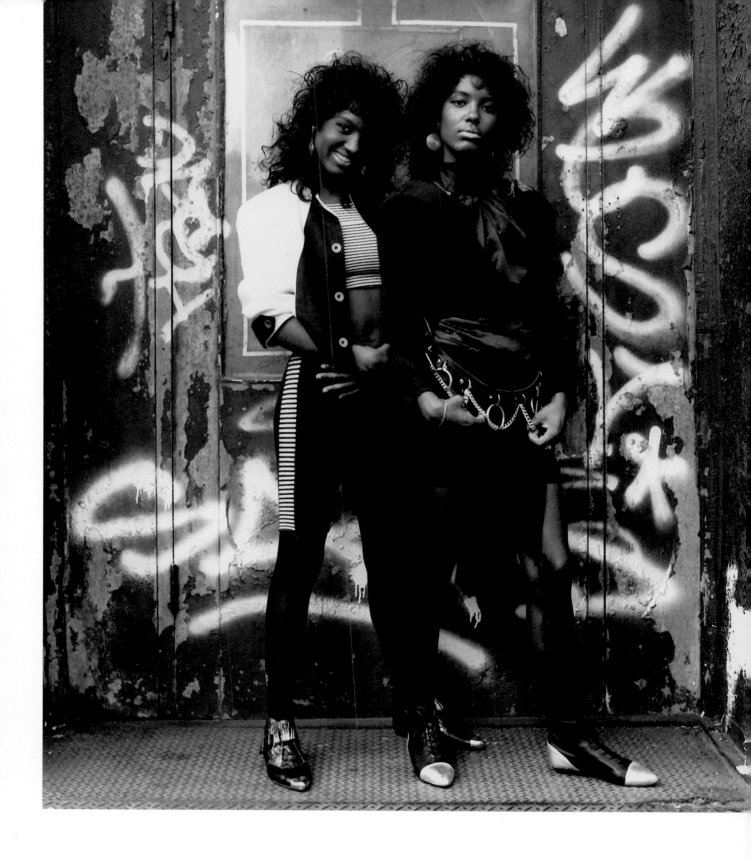

PATTI ASTOR
Fun! The True Story of Patti Astor

The 1982–1983 season was a peak year at the Fun Gallery. Every show was a blockbuster, including those by Keith Haring and Kenny Scharf.

Kenny's show installation started off with a huge fight with Tony Shafrazi, who had sent over Kenny's paintings, including a twenty-five footer designated "not for sale." He also informed me, through his assistant, that he would be "handling" the sales for the paintings in the Fun! I got on the phone and

Photograph by Martha Cooper

When you had a really important show there was always a feeding frenzy. Dealers and collectors would want to be in "first" before the opening and the gallery would be filled with little knots of intrigue.

For Kenny Scharf it was like the Fulton Fish Market—maybe it was the beach theme and the sand on the floor. Six hours before the opening it was pouring rain and inside the gallery I was juggling three groups of people, each trying to pretend to ignore the others.

Two Italian dealers from Naples were there trying to beat me down in prices. Rich socialite Elaine Dannheiser was there trying to find out what everyone else was buying, and Estelle Schwartz, original Art World Barracuda, was there with one of "her collectors." Estelle advised "her collectors" to spend the big bucks. As you can imagine she was one of my favorite people. The "collector" was a perfectly-coiffed little lady, mink coat and Enna Jetticks, top of the line Mercedes-Benz with chauffeur outside—the usual.

I was rushing from one to the other in the art world version of *Let's Make A Deal*. (The door, no the curtain, $10,000 in cash!)

Suddenly there was a tremendous BOOM! and CRASH! against the door—the entire building shook! With my Students for Democratic Society background I was convinced someone had thrown a bomb at the front door—probably Tony Shafrazi, my SoHo archrival!

I rushed to the door and opened it—to be confronted by a huge pile of soaking cement and steaming rubble. Looking up I saw that it was just another piece of the Fun giving up the ghost—the heavy rain had soaked into the cement and caused the entire roof of the outside entrance to crash down. Six hours later there would have been 100 people standing there.

The Italian dealers' reaction was "Come now Mees Astor, let's make it $7,000." Elaine Dannheiser hadn't moved. I was always convinced she could neither see nor hear but perhaps she felt the vibrations—let's be kind and say she stood stunned. As for Estelle's collector, she made a run for the door. Her EJs flashed over the ruins and she hit the back seat of the Mercedes in a record eight seconds. Chauffeur James peeled off.

Estelle turned to me with a scornful look on her face and said, "She'll never be a real collector."

Oh, as to the hundreds of almost victims who crammed the gallery six hours later, the champagne flowed. We served individual splits of Henkell with a straw, for, you know, the beach theme. Clamoring over the hulking piles of dripping concrete they cried, "Patti you always have the *BEST* installations!" ▣

informed him that this was the Fun Gallery not Tony Shafrazi Gallery, at which point he self-detonated.

"What do you mean, I feel like this is the Fun Gallery in SoHo! All I hear is Fun Gallery, Fun Gallery, I'm sick of it!" He was screaming so loudly I thought he was going to have a fit so I hung up on him, called back one of his assistants and told her Tony needed an ice bag on his head. Bill and I "handled" the sales.

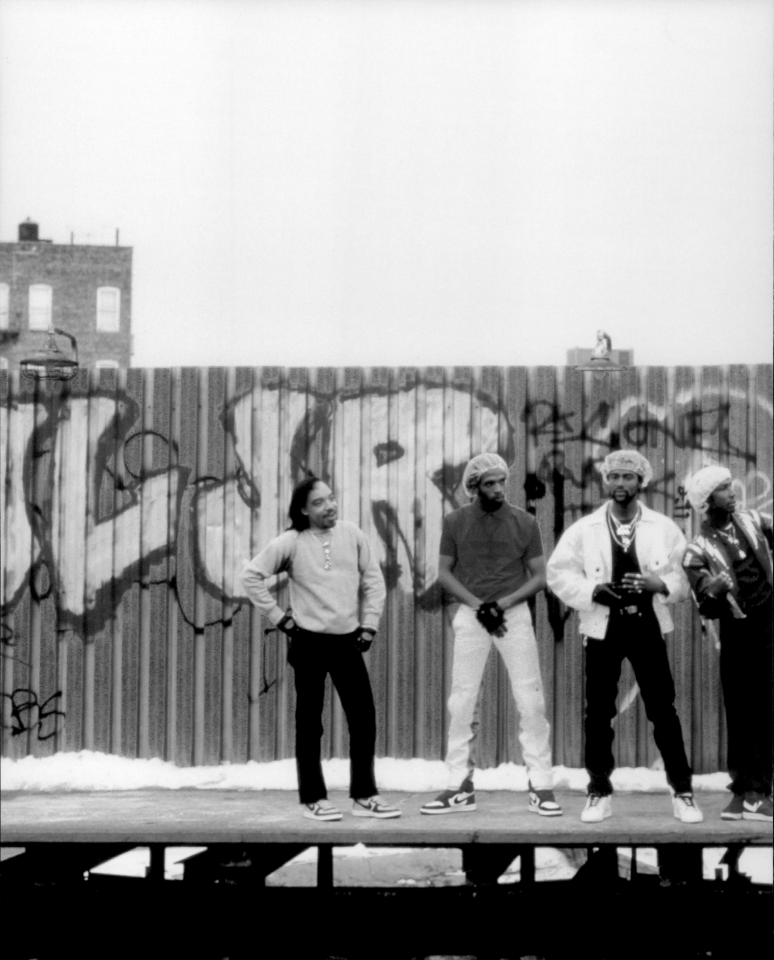

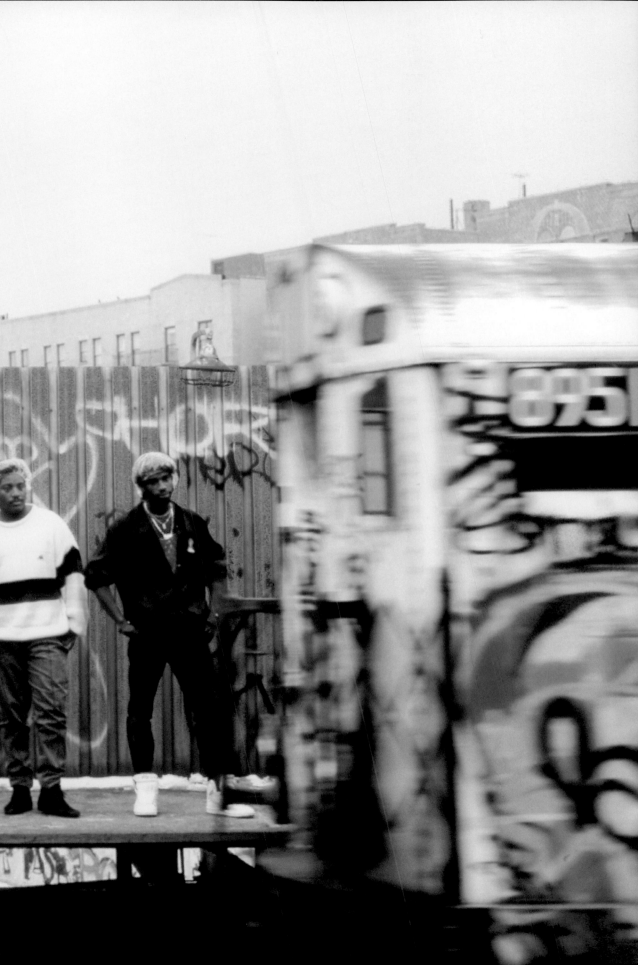

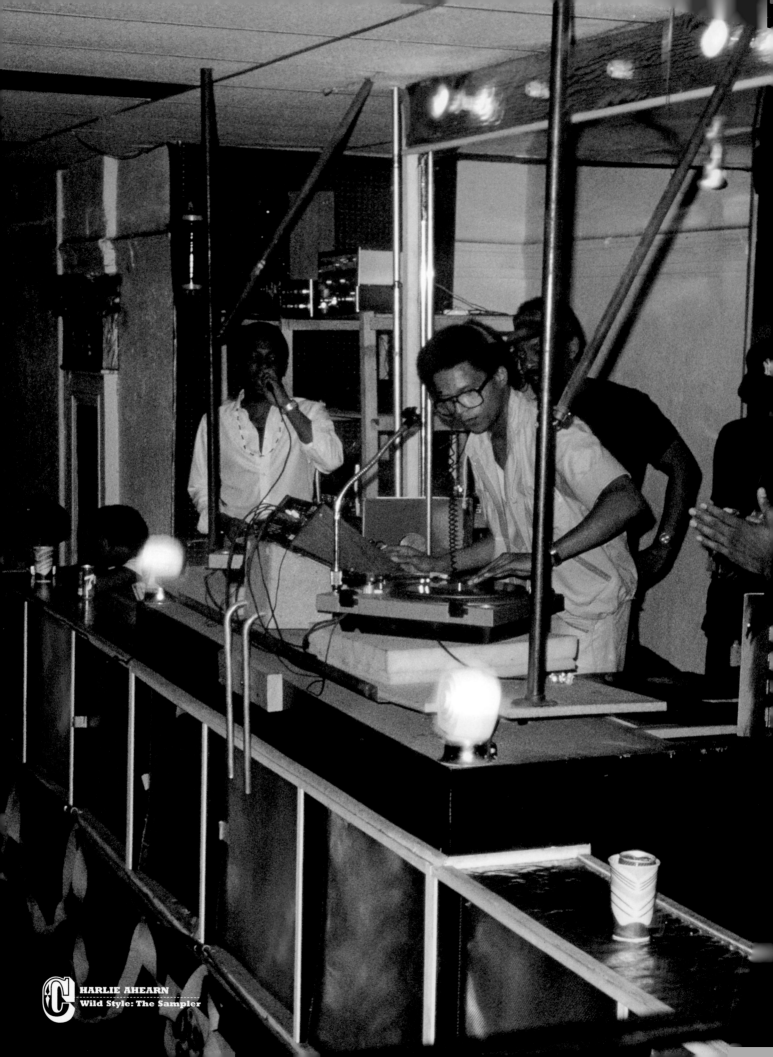

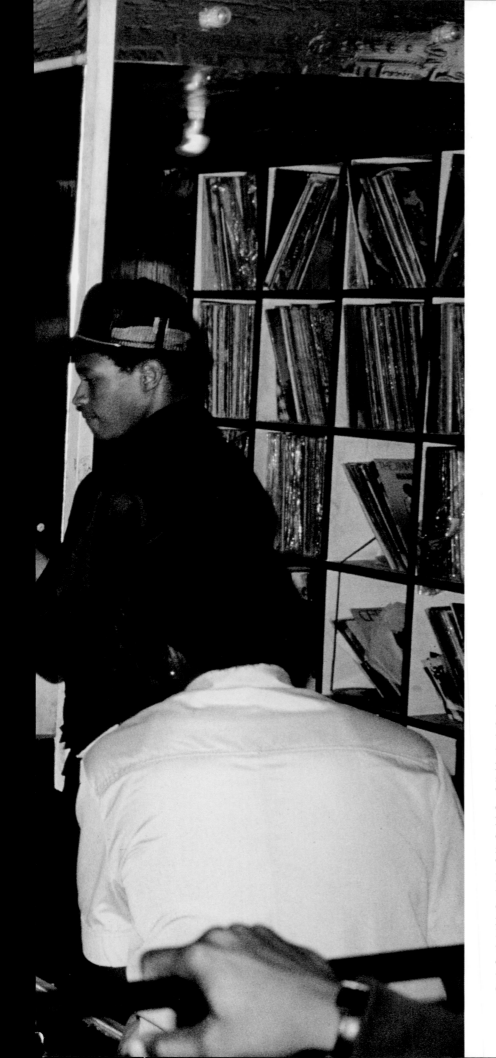

That summer of 1980 Fred Braithwaite and I were going up to parties in the Bronx several nights a week. Around midnight we'd take the IRT almost to the top of the map to step out at Gun Hill Road and peer over the railing to check out the crowd three stories below us trying to get into The T-Connection. The "T" was named for it's owner, Richie T (RIP), one of the great pioneer DJs and the owner of The Rhythm Den on East Tremont, where you could purchase $5 cassettes of Zulu, Cold Crush, and Flash party tapes from any year. The "T" was also the original home of The Brothers Disco—later called The Funk Four. You had to walk up three flights of rickety wooden stairs to a large, open gymnasium with a generous stage area and across the room, high in the corner, a sort of professional DJ booth with panels of flashing disco lights. I saw The Fantastic Romantic take the stage with Wayne and Charlie the rapping ventriloquist and later The Chief Busy Bee rocked the crowd from the DJ booth with Kool Herc's original partner DJ Clark Kent. ◼

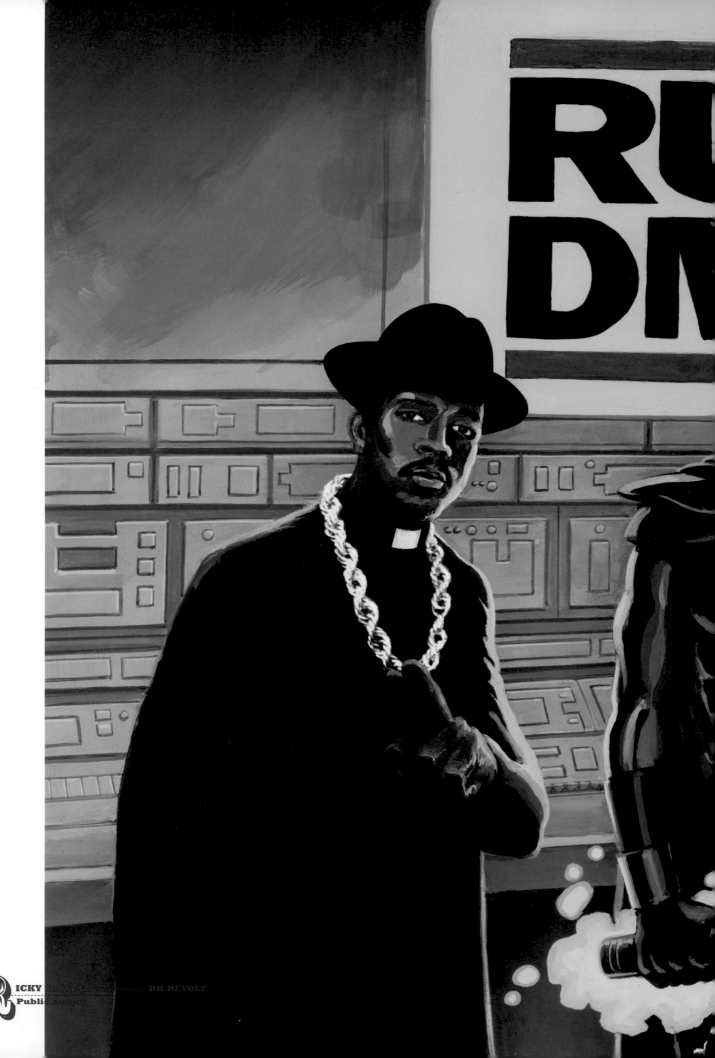

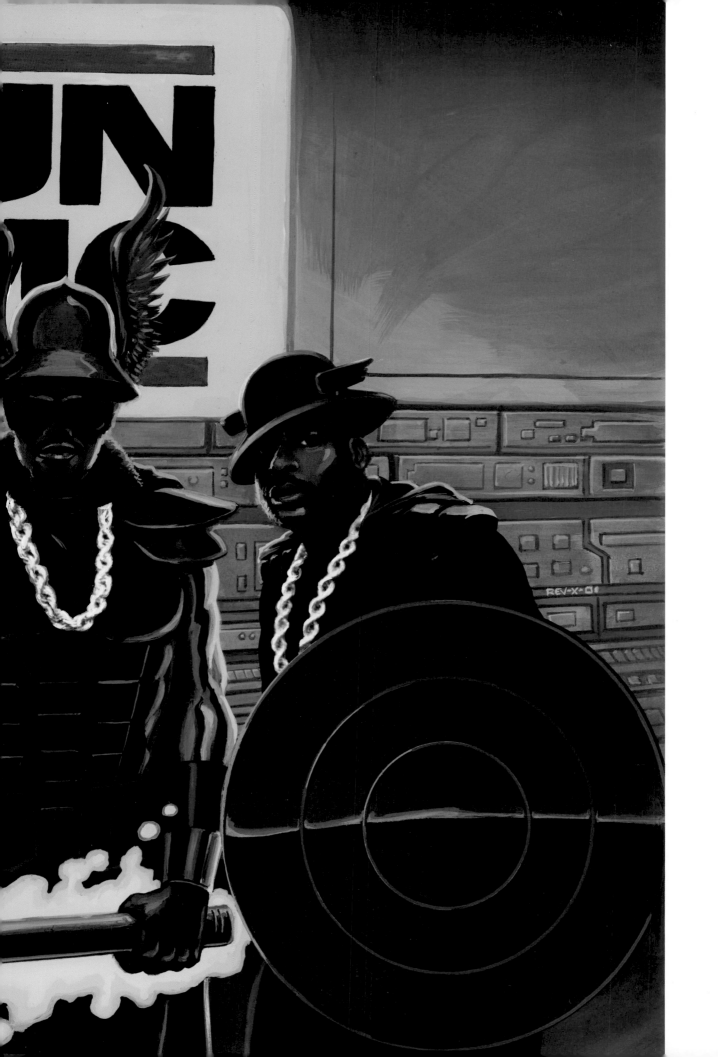

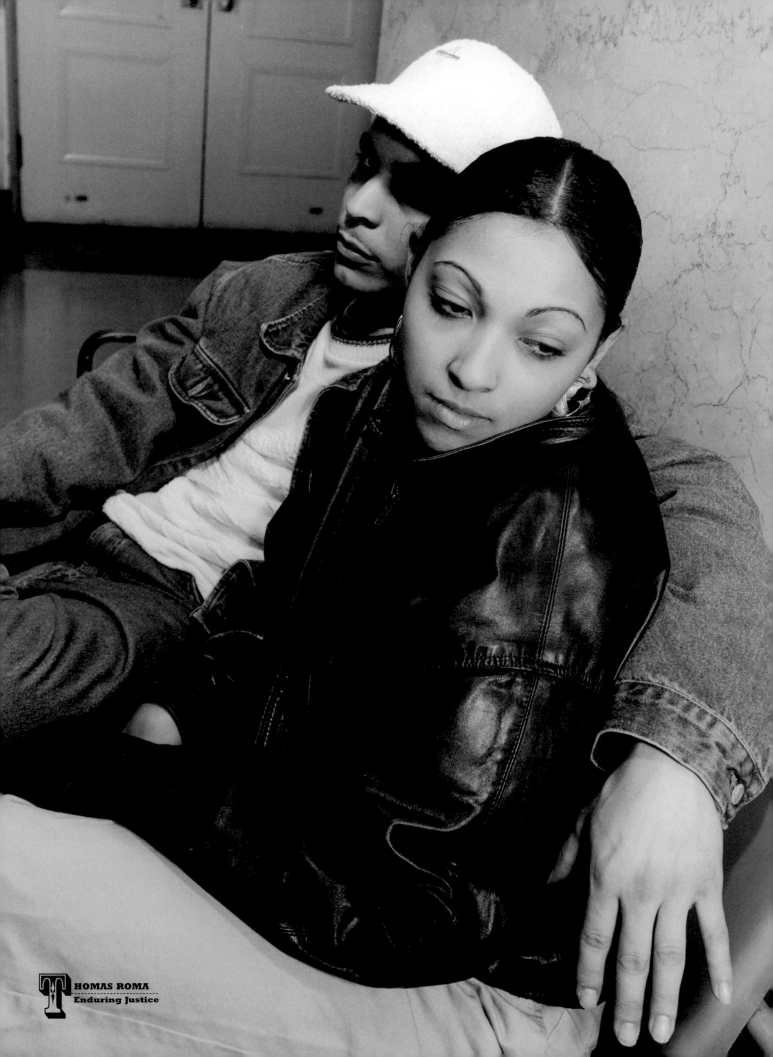

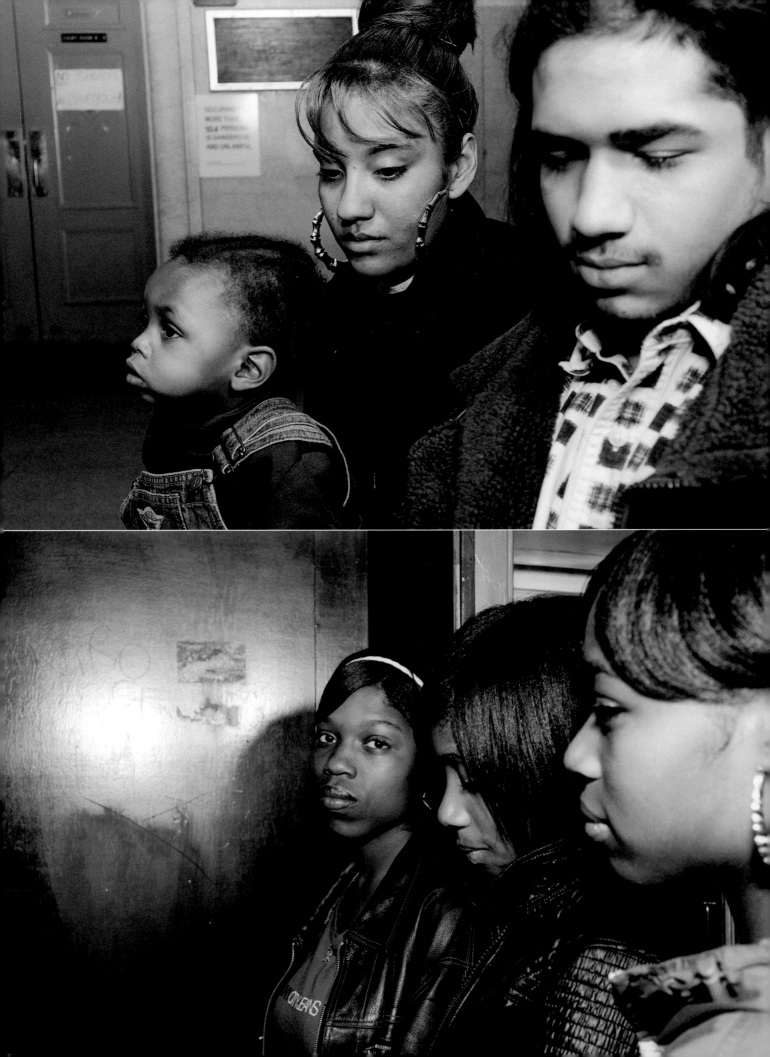

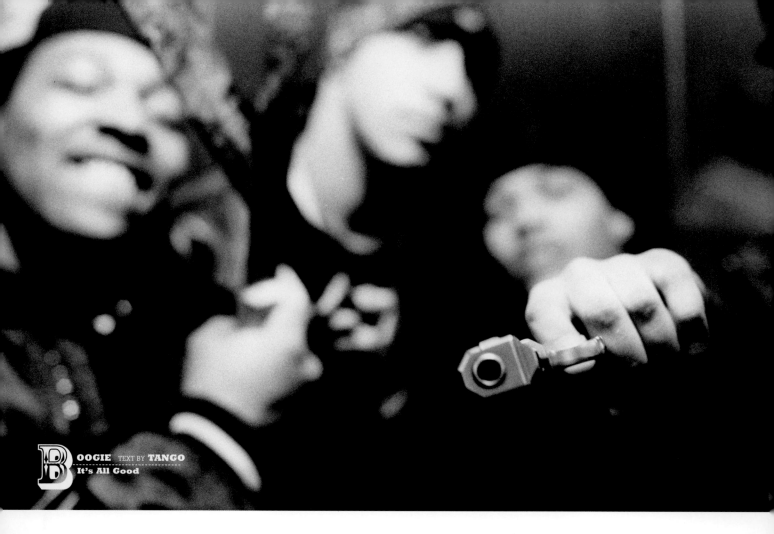

I am what they now call an OG: Original Gangster. Back then, we had Devil Rebels, Dirty Ones, Bikers, Savage Skulls, the Lawmen….All gangs used to dress the same so we would cut off the sleeves of our jackets and we would put lettering on the back to identify our gang. I was in the Devil Rebels and my street name was Blaze.

When one of the Bikers was killed, they put him in the funeral home in Central, but that was Devil Rebels turf. We didn't agree to having the funeral there, so we started fighting with Bikers. Our guys ran inside the funeral home, took the body out of the coffin, dragged it to the middle of the street, and beat the shit out of the dead body. We had it all planned out when we started hitting the funeral home: when Bikers were coming to get us, we each grabbed a bottle and threw them at the same time. It looked like a million bottles up in the air. It looked like it was raining bottles. We had sticks and bats hidden under the cars so when we ran out of bottles everybody started grabbing sticks and bats. Bikers didn't have any weapons 'cause it wasn't their turf; they had nothing prepared. It was like the movie *The Warriors* back then.

In Devil Rebels, we had different divisions: Division 13, Division 5, Division 1; from the Bronx, Queens, Staten Island—every borough. We had all the divisions come down to Cypress Hill Park in Queens because we were going to fight the Savage Skulls. They only saw six of us in the park ('cause the rest hid on another block) so they figured they were going to destroy us. So they came rolling down, I think 30 of them, and wanted to surround us. But

when these guys looked around them, there were close to a thousand Rebels. They had nowhere to run, nowhere to hide. The only way they were going get by us was to fight. They were so outnumbered. Savage Skulls was a big gang and we thought they were going to come down with all their divisions. We didn't know it was going be just one division there to fight.

We dressed differently than the kids now. We had red hankies tied to the MC boots. When you bought these boots in the store they already had a one-inch heel and we used to add another three inches. They also had a belt through the bottom and a belt through the top; we would put nails or razors in the soles so when we had to kick some heads you would have nails stabbing the person.

The cops never made problems for us—times were different then. In the 60s and 70s, if they caught you with a gun, all they would do is take it away from you, smack you in the face, and send you on your way. There were no arrests. You would get caught with a gun and you would get away with it. In the 80s, the gun thing became tougher; if they caught you with a gun, you would get a year automatically. Now if you're caught with a gun you go to prison for two or three years.

Now everything is guns; everything is a shootout. Back then, everything was a chain, a knife, bats, machetes. There were no guns. But aside from that it was exactly the same as it is now: if you didn't belong to a gang, you were a punk in the streets. You have to belong somewhere. If you were a normal person, it was dangerous. Sometimes the gang

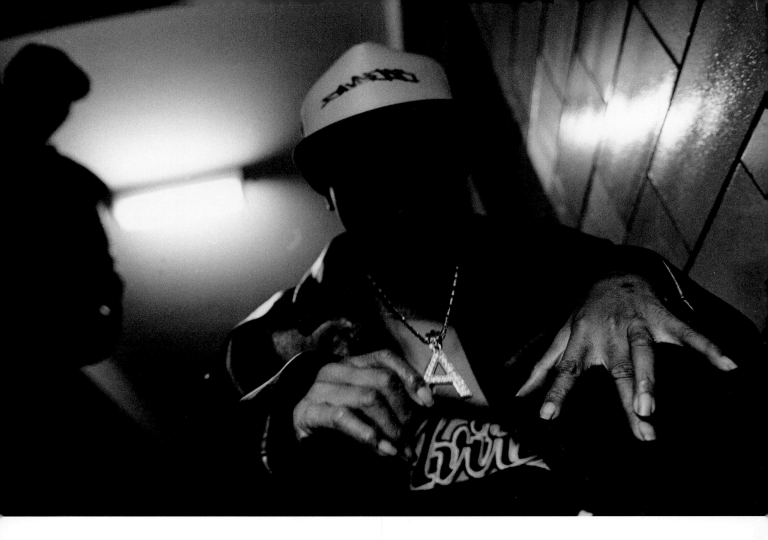

members would rob you. Back then it wasn't about money; it was about sneakers: Puma, Nike, Pro Keds, and Converse. Pumas were about 25, 30 dollars, and in the 70s and that was a lot of money. So they would take your sneakers.

Back in the days, we were defending our turf. We wouldn't allow anyone to come to our turf and rob anybody. The only way that a person was going to get robbed was by us. Back then it was more dangerous but you had better chance for survival. Today no one fights hand to hand. As soon as you pick up your hand, the guy is pulling out a gun and you're gone. Back then if you were a good fighter you would survive. These guys nowadays don't know how to fistfight.

These days the gangs, like the Bloods…I wouldn't even call that a gang because they have Bloods fighting Bloods. In our time, if you were a Devil Rebel you were a Devil Rebel no matter where you went, and you had respect from all other Devil Rebels. They would look out for you. We weren't fighting each other. That wasn't allowed. The only time there was a fight was when you were fighting your leader to take over the gang. There were different positions in the gang—leader, lieutenant, lieutenant of war, chief of war—and if you wanted any of these positions, if you felt you had the balls, you had to fight that person for that position. And it would be a freehand fight, fist to fist. If you knocked him out, he lost the position. Nowadays, gang members are fighting each other. They don't need to fight other gangs 'cause they are turning on themselves. What do they need other gangs for…

After my gang period I started with the Guardian Angels, Kasciusko Patrol, when I was 18 or 19 years old. Guardian Angels were there to protect the people. There were too many crimes at train stations: girls were getting raped, there were muggings, fights, slashings. The cops were doing nothing. Government was doing nothing about it. This is where Guardian Angels came in. They used to call us vigilantes; the order was to arrest Guardian Angels. My patrol was the first to get arrested.

I became a cop after I got married. I left the street and joined the department. The smartest cops on earth are those that were gang members, people who know the streets 'cause they have been through everything you are going through now. I was a cop in the same neighborhood where I was a gangster— Bushwick. Same neighborhood. I met a lot of people I used to hang out with and they just couldn't believe it. Life changes.

After 11 years I left the department, I resigned. You see so much out there that you don't see on the news. People think just because you're a cop and you're making good money, you're the law and you can do whatever you want. But when you become a cop, it's a different world. It's not easy to explain their world. It's hard. It's very hard. To be straight up, I became a drug user. I was into cocaine a lot. I just couldn't take it anymore. I resigned as a sergeant. I got myself together again and moved on. I think that was the best thing I did.

I'll always be a gangster, until the day I die. ◼

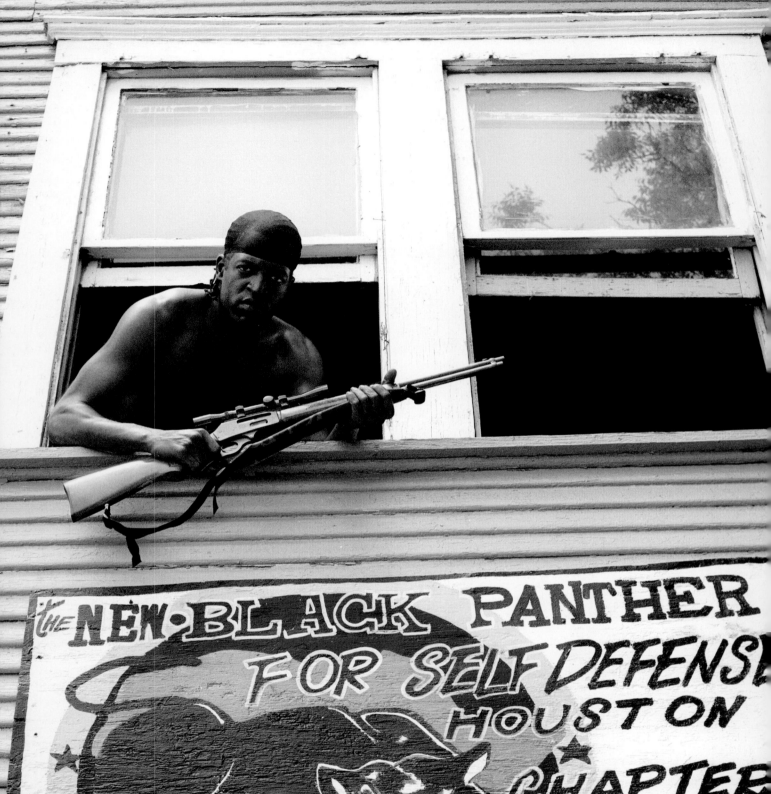

THE NEW BLACK PANTHER FOR SELF DEFENSE HOUSTON CHAPTER

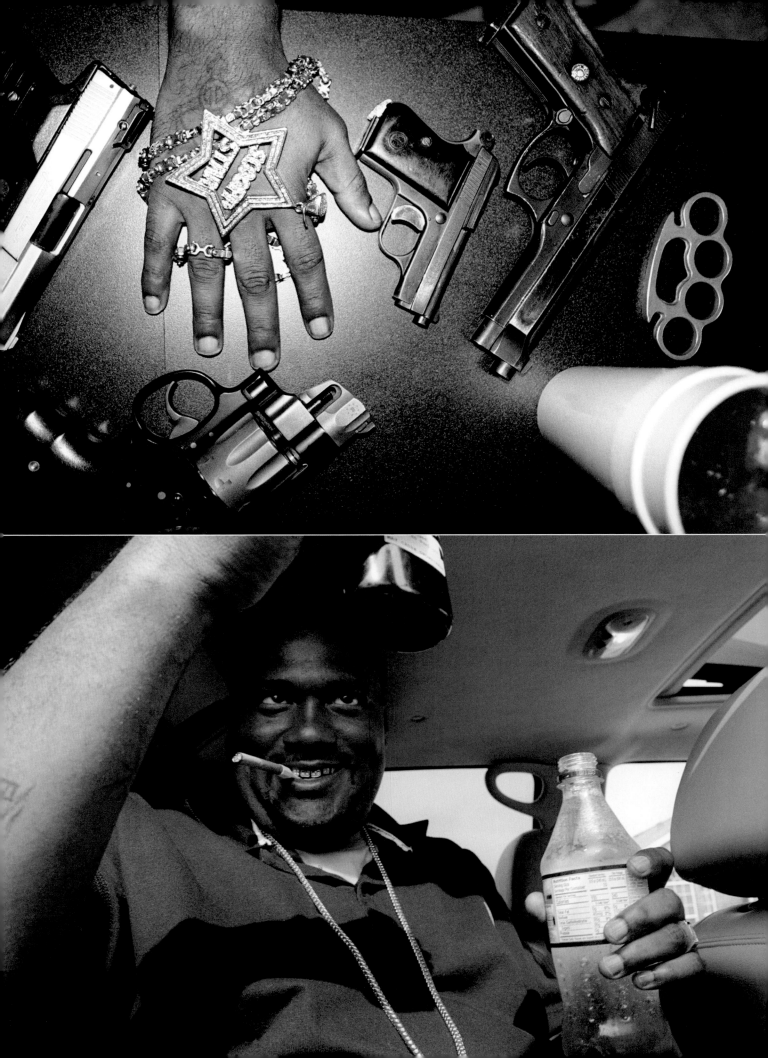

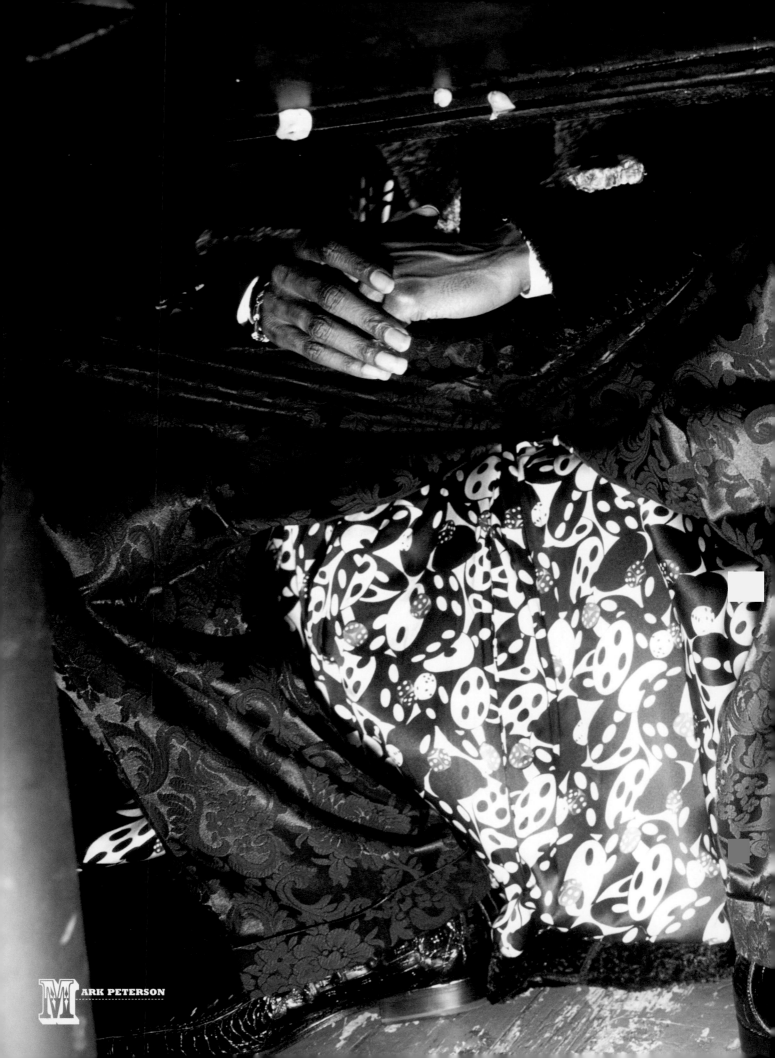

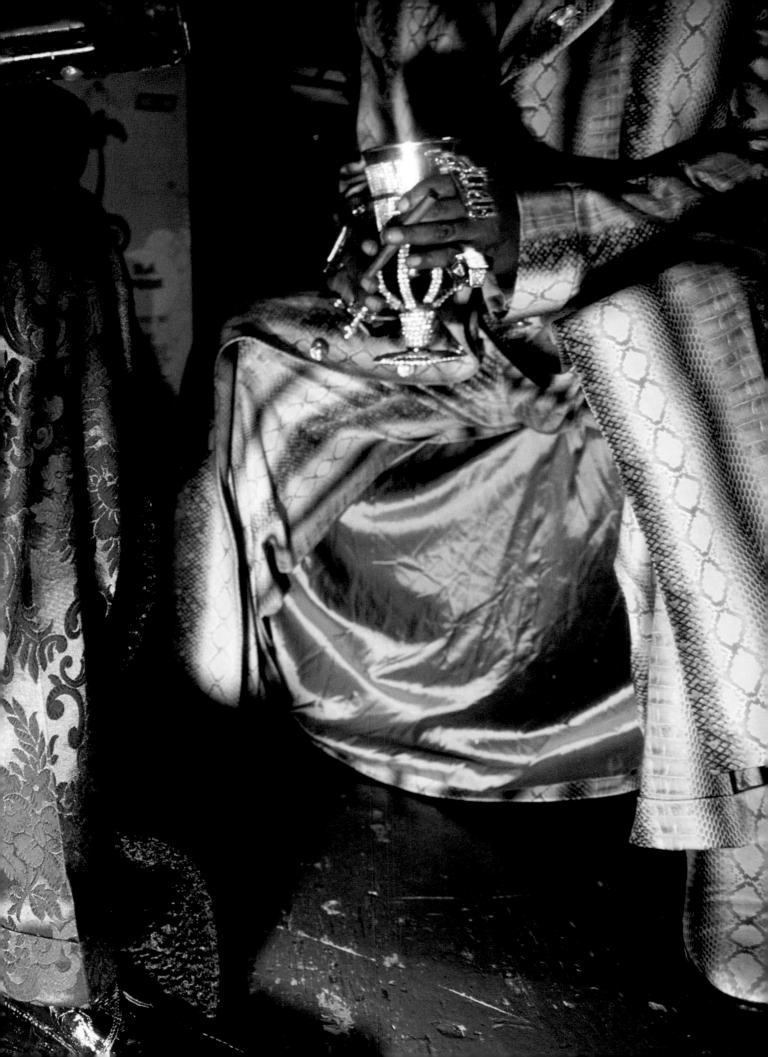

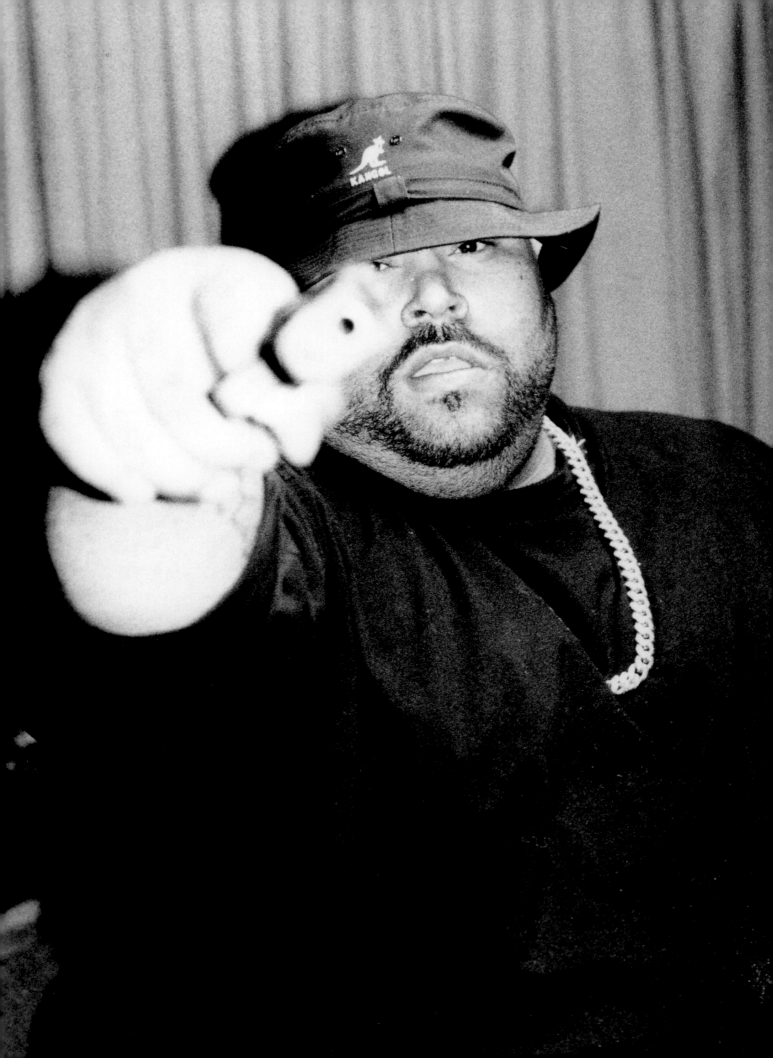

CHRIS NIERATHKO

I'll start by saying I have always had a soft spot in my heart for obese rappers: Fat Boys, Biz Markie, Chubb Rock, B.I.G., Fat Joe—I love them for their talent but also because there is something warm and cuddly about a big ass dude rhyming. So you can imagine my elation when I first saw Big Pun taking up most of the screen in The Beatnuts' *Off The Books* video. His underground single *I'm Not a Player* was making a lot of noise back in 1997 and I called his publicist to meet him in person for an interview. If you're not familiar with my style of interview, I'll just warn you: it's confrontational. They go one of two ways: bad or really bad, with rare exceptions. One out of every hundred interviews I meet someone who has a sense of humor and rolls with the punches and actually punches back. Pun was that guy. He was amazing: charismatic, genuine, and had the best sense of humor of anyone I've had the pleasure of speaking to professionally.

When I walked into the Loud Records offices I was carrying a case of Heineken, two blunts, and a bag of weed. I handed him the gifts and shook his hand. He asked why I'd brought the beer and weed. I simply said, "Because this is going to be the worst interview you're ever going to have." He started laughing immediately. But I wasn't kidding. Back then both Pun and I were a lot skinnier. I was a mere 140 pounds and anorexic, and he was only 400; a little more than half of what he weighed at the time of his death. Regardless, I told him, "All I have are fat

jokes." Again he laughed. We had a few beers and got to know each other before the verbal jabs began. Then I set in. The beauty of Pun was he laughed at every joke and hit me with insults right back. He insinuated I looked like someone in House of Pain and also a Nazi. For an hour we made fun of each other until it was time for me to take some photos. Head stood up, I bent down to fetch my camera from my bag and when I looked up I had a 9mm pistol pointed inches from my nose. My world collapsed. I was probably hyperventilating. Shook doesn't begin to cover how I was feeling. In all honesty, I believe I shit my pants. I began stammering, choking on my words. His face was stone cold. I tried to explain, "Listen…fuck…I'm sorry. That shit I said before…God, please don't shoot me…I was just kidding about the fat jokes…" Finally he cracked a smile and said, "Gotcha." I nearly fainted. I got my photos, he got the last laugh.

Since his death I've bumped into Fat Joe and JuJu and Psycho Les and they always tell me the funniest Pun stories. One of my favorites is how whenever people would leave their cellphones lying around he'd grab them when they left the room and stick the phone under one of his belly rolls to stink them up. Some people nearly vomited the next time they took a call.

No disrespect was intended, nor any taken. I love Big Pun and will to the day I die. The world was cheated the day we lost him. May he rest in peace. Why is it always the fat ones that have to die? ◘

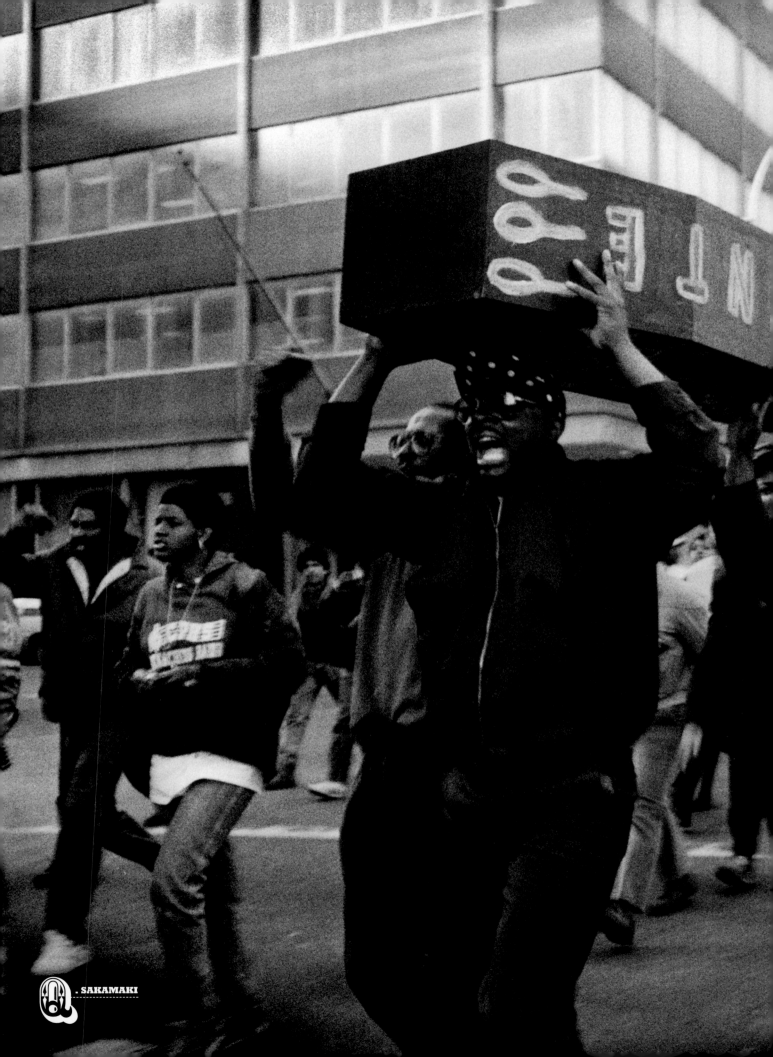

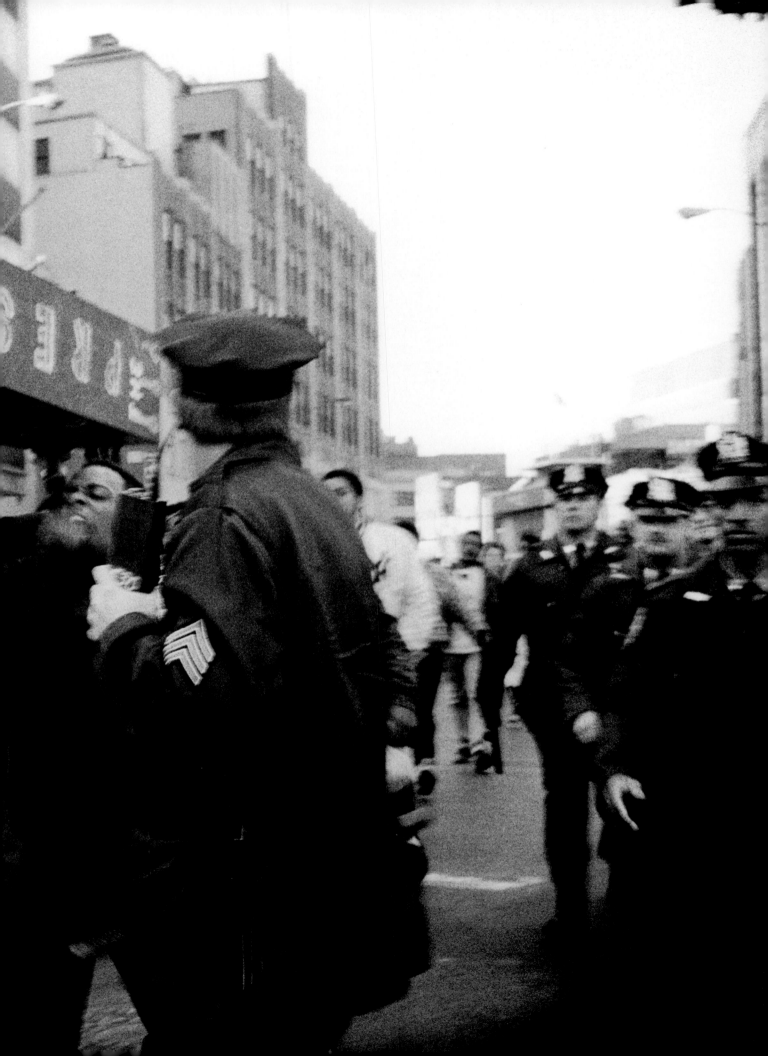

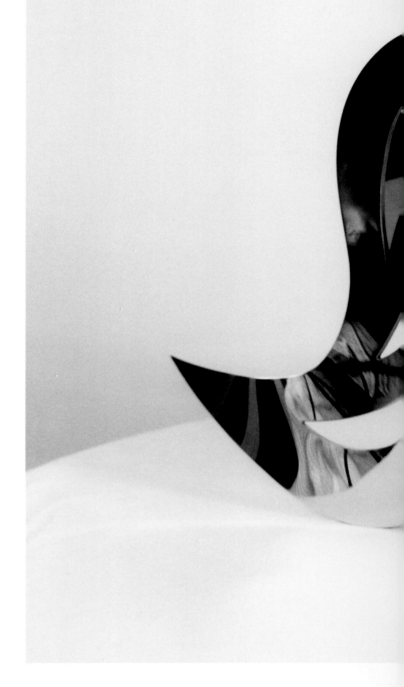

One artist who has successfully incorporated the so-called high and low streams of contemporary art in his work is Carlos Rodriguez, aka MARE 139. A veteran of the golden years of New York subway painting from 1978 to 1983, Rodriguez began his art career wielding a spray can to do burners on parked trains under the cover of darkness. He learned to paint not in school but as an apprentice to older graffiti artists such as his brother, KEL 1ST. You might think that the upper reaches of culture would have been inaccessable to a youth who was working in an outsider art mediuim, like graffiti, and living in New York City in a time of economic crisis. But even though the public schools had eliminated art and music programs, the city still offered a wealth opportunities for a curious young artist to learn about art. In spite of its difficulties, New York was still a place where you could see all the art of the world, both from a historical perspective and in contemporary art galleries showing the best current work. In the case of Rodriguez, the untutored teenage graffiti artist attended the large Picasso retrospective at MoMA. This and other eye-opening experiences encouraged the young man to consider art as a career choice for his life.

As graffiti evolved in the 70s, and wild style emerged as the predominant style, the components of colors, designs, fades, arrows, and pumps gradually coalesced into a quasi three-dimensional form. In fact 3D became one of the building blocks of most graffiti pieces. Wild style pieces, the invention of urban adolescents, resemble a frieze, autonomous with respect to the surface and suggesting three-dimensional relief. Several graffiti artists, MARE139 among them, saw the possibilities in taking a sculptural approach to the letter forms, moving from the illusion of depth in painting to concrete forms in sculpture. At first most of these sculptures were executed not in the round, but adhering to the format of a relief, to be viewed from only one point. Rodriguez's first pieces on sheet metal were like drawings of the shape of the letter, with sculptural form created by cutting and bending the flat metal plane that faced the viewer so that it swelled and receded to define volume.

During the late 70s and early 80s in New York, the cultural scene was a blend of avant-garde artists looking for new ideas and strategies, encountering outsider artists from the marginal neighborhoods of the city. The latter realized that they weren't alone, as artists, and that the city was teeming with their peers and with many alternative venues besides the subways. Curious and inspired to look further, Rodriguez came upon the works of Frank Stella and was struck by the way these sculptures resonated kinetically and rythmically with his own sensibilities—honed by painting art on a moving object. Rodriguez, still working predominantly in

reliefs, was able to jettison much of the graffiti imagery from his palette and to work in a non-objective mode, deepening the relief, incorporating textural variety and line with sheet metal, grids, wire, and steel rod. At the same time, he was working on paper models, using some elements of graffiti without necessarily doing letter forms. He explored many variations on the arrow, a symbol that suggests movement and direction and one of the elements that gave traditional train graffiti its nervous energy and dynamism as an artwork bred on a moving object. Rodriguez expanded this route of inquiry to larger paper and metal works and castings utilizing the arrow and other forms derived from graffiti. It is the emphasis on movement within a mechanical, industrial context that relates his work to a large body of 20th-century sculpture.

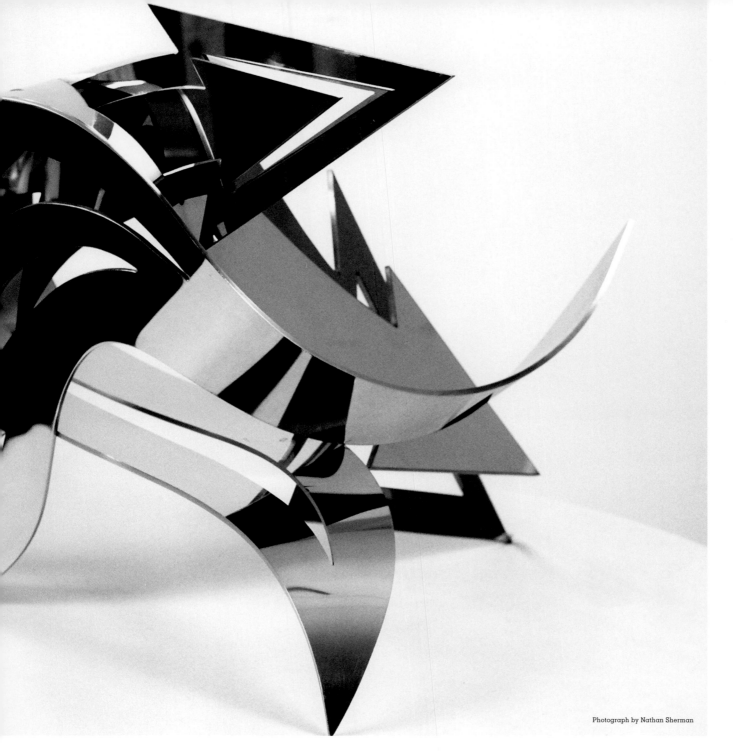

Photograph by Nathan Sherman

Rodriguez began peeling back the layers of modern sculptural idiom to look at the Russian Constructivists and the openwork drawings in space of David Smith, which are in turn rooted in the earlier sculptures of the 20s and 30s of Picasso and Gonzales. Iron-work, forged sculpture has its origins as much in industrial technique and the detritus of the industrial age as in fine art. Not taught in art schools until after World War II, industrial metal working had to be learned at first in technical schools and then on the job in shipyards and auto manufacturing plants, as with David Smith, or in the decorative iron work fabricating shops of turn-of-the-century Barcelona, where Julio Gonzales once worked. Rodriguez, in keeping with these industrial roots, learned welding and metalwork at a New York City technical school. With the influence of these earlier sculptors and through his mastery of metalworking technique, Rodriguez began to discover the possibilities of utilizing metal to create form and volume with planar and linear elements in the immaterial air and space that surround all life. His latest sculptures are now fully realized in the round and to move around them is to watch the shapes of incised space come in and out of focus as if in a kaliedescope, as new shapes in space come into being. Never completely abandoning the imagery of his early years, he often uses the letter as a point of departure to explore sculptural form. In Rodriguez's work, there is a lingering flavor of the post-modern movement of outsider art that was embraced by the New York and European artworlds of the 80s, now fused with a sculptural language deeply rooted in modernism. ▣

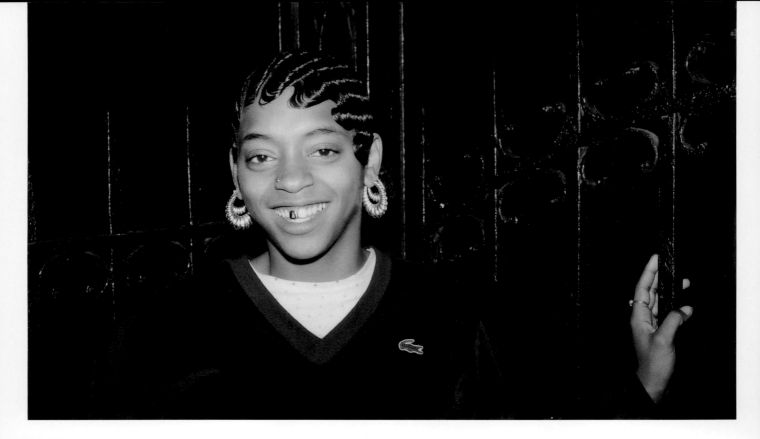

 ISS ROSEN

I checked my bags at the Luftansa counter at the Frankfurt airport with hours (to say nothing of Deutsch marks) to drop and needing to eat 'cause I had been up for a week, so I stopped in some spot in Terminal B not far from Escada and entered, exhausted and starved, smoking a cigarette for strength. I was waiting to be seated when some young German came up and stopped like what.

The lad was speechless, but not for long. "Who did you hair?" he asked with his eyes wide open, dilated pupils showing.

What sort of service is this, I wondered. "I did," I answered effortlessly and glanced longingly at the tables underneath the panoramic window overlooking the tarmac. Airport dining: pathetic yet soothing.

My gaze went ignored by this pastycake whose pale eyes blinked in disbelief at my response. Looking strangely alert, he inquired, "How?"

I was amazed he cared when all I wanted was a chair. And a menu. "I pulled it back," I replied.

"And then what?" the young buck quickly followed up, shifting his stance in anticipation.

If I had the energy, I'd snicker. Ohh. Snickers. Do they have those here? Wait. What is he bothering me about? That's right. My hair. Aiii! Why does he care? "I put it up," I said succinctly, willing him not to dive in to a discussion of tools, techniques, or products.

The German guy nods admiringly for a moment. Then he declares, "It's so black."

It's so black and I'm so not, so I had to know what he thought. "What do you mean?"

He looked at me then focused intently on an image in his mind and searched for the words to verbalize the vision that had him tripping. "It's so black…like from the Bronx."

Slightly aghast, slightly a gasp—fuck it—completely taken aback, I spoke slowly to make sure I spoke correctly. "I'm from the Bronx."

My words caused his circuits to short or so it appeared 'cause he shifted gears with the speed of light years and asked with a bit of whist, "Do you think I could do my hair like that?"

(Is he on crack?)

Let me tell you, "like that" looks like this: Spiral curls slicked back into a ponytail, my face framed flawlessly by a hairline waved like a flapper bitch with a switch in her walk who'll make you twitch when she talks.

Back to the German. I looked at his lid. Nothing happening. Just a buzz cut in a fair blonde, a Nordic color I once strove for—before it all fell out at the crown due to excessive exposure to extensive bleaching treatments in the bathroom. Not that this stopped my platinum ambition; I just cut it all off and kept going (until people started calling me "Madonna." Yeah, that did it. Back to brunette.)

Meanwhile, his hair was thin in both texture and distribution so I decreed, "You need a weave."

He looked lost.

"You need extensions." If at first you don't succeed, repeat yourself.

His blank look defied me, defeated me. One glimpse into his crystal clear eyes—clueless to a world where women wear fake hair made from real human hair or better yet from plastic—left me unable to bridge the divide. I was tired. Weary. Hungry. "Can you take me to a table please?"

Moral of the story: There are no beauty supply stores in Frankfurt, or at least not in this airport or on any block I spotted—but lots of blocks (and train stops) got graffiti and a few of them pieces was hot so you've got to wonder what's goin' on in a city where this Jewish bitch from Rivahhhdayle is black, like from the Bronx. ◪

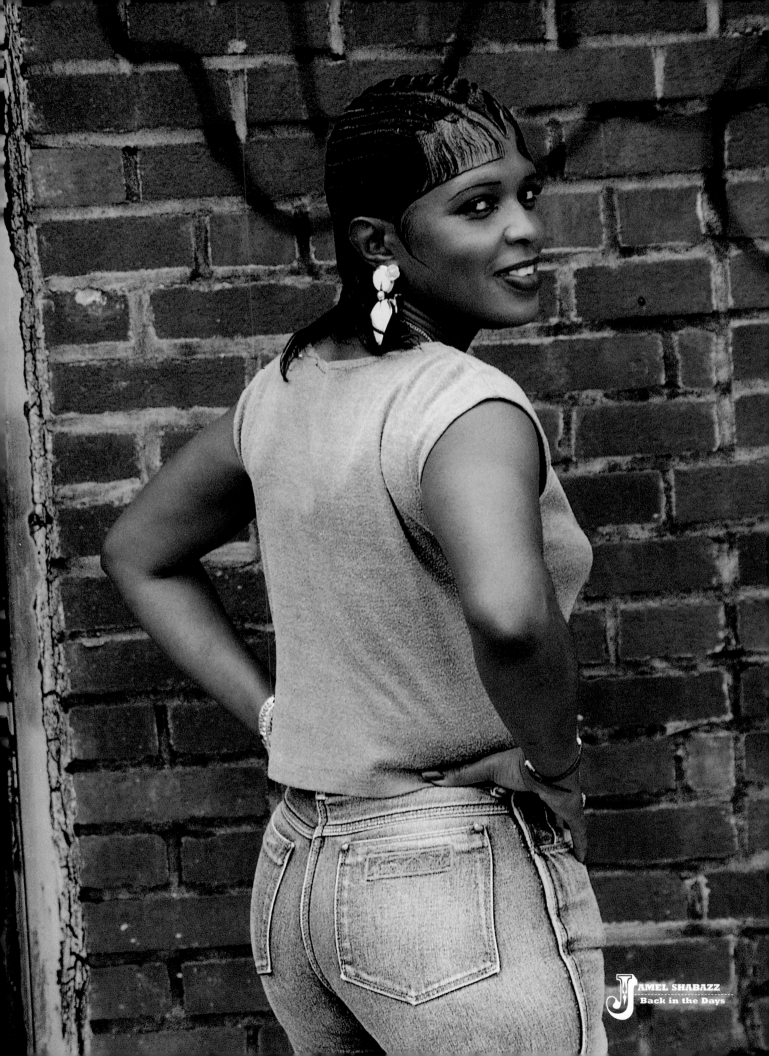

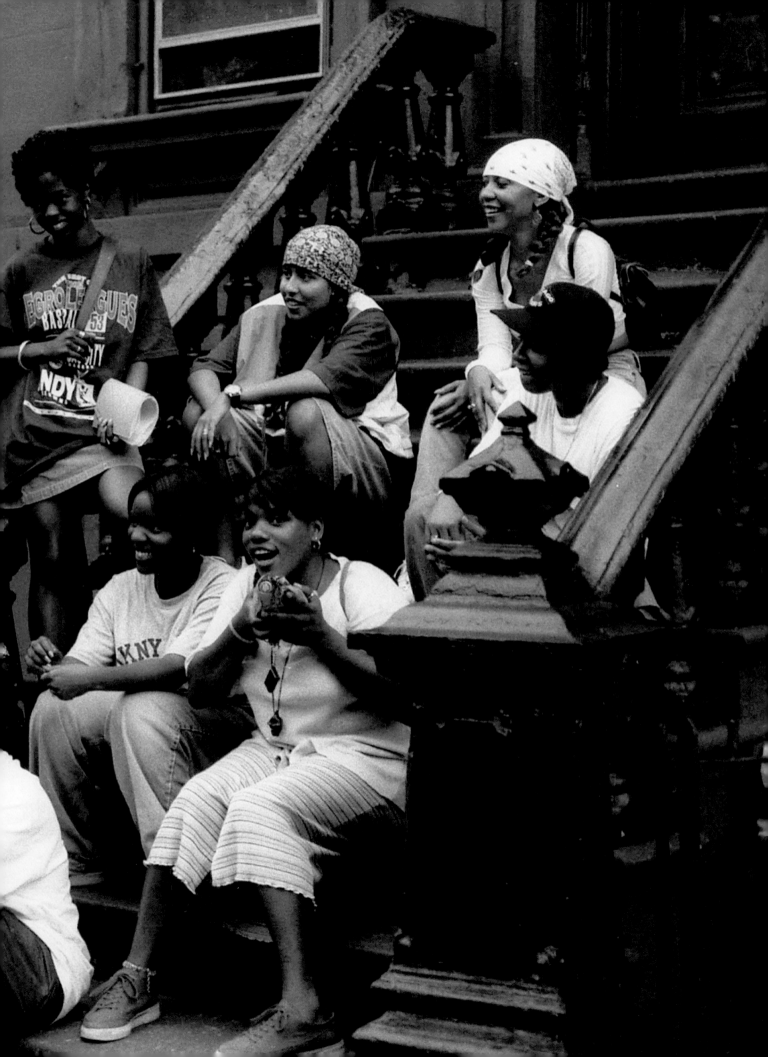

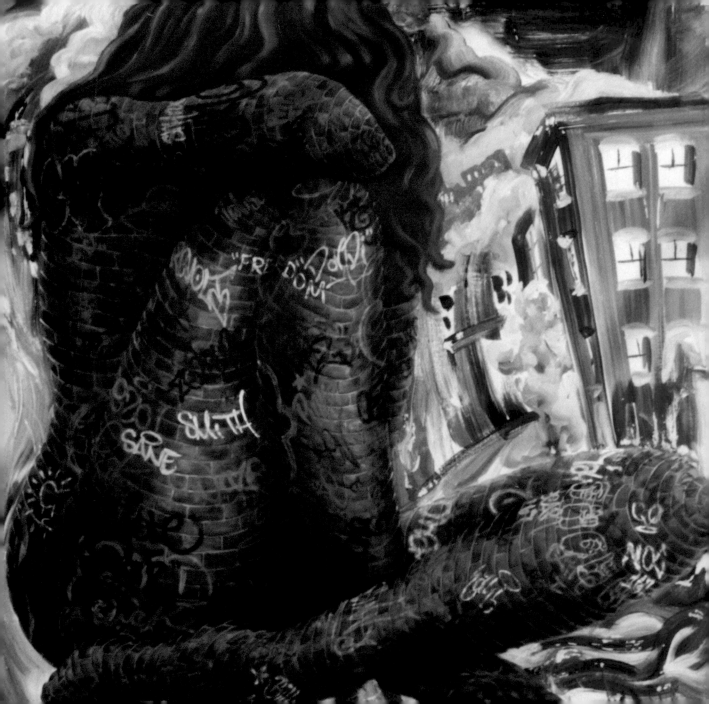

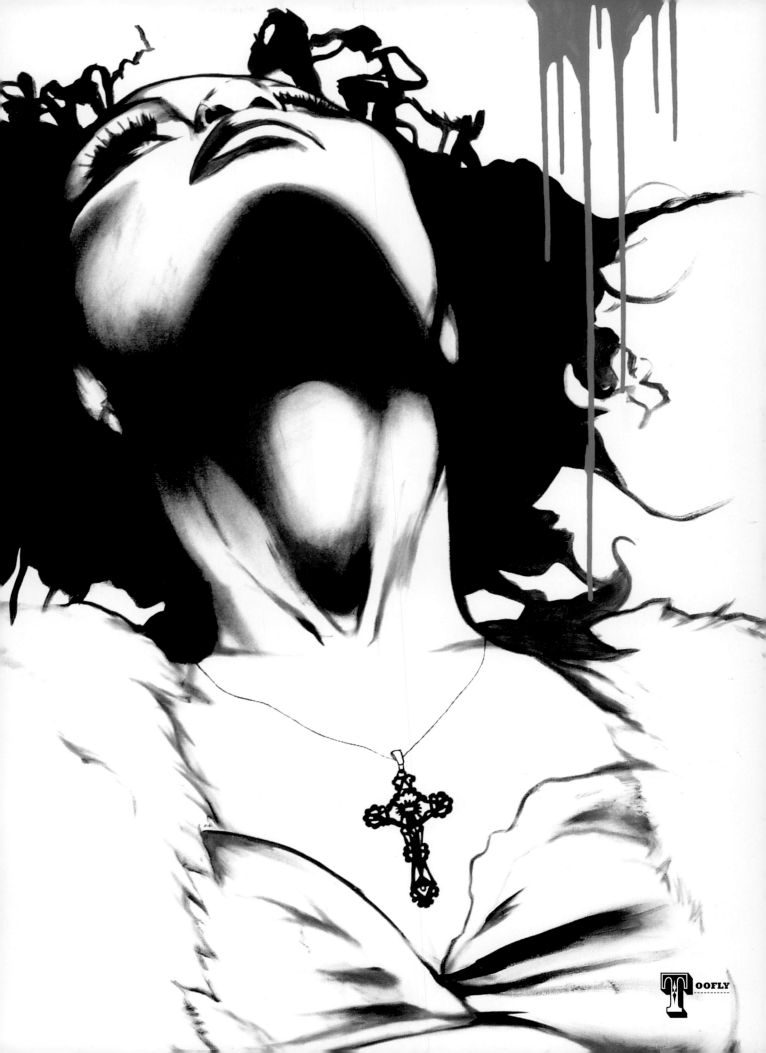

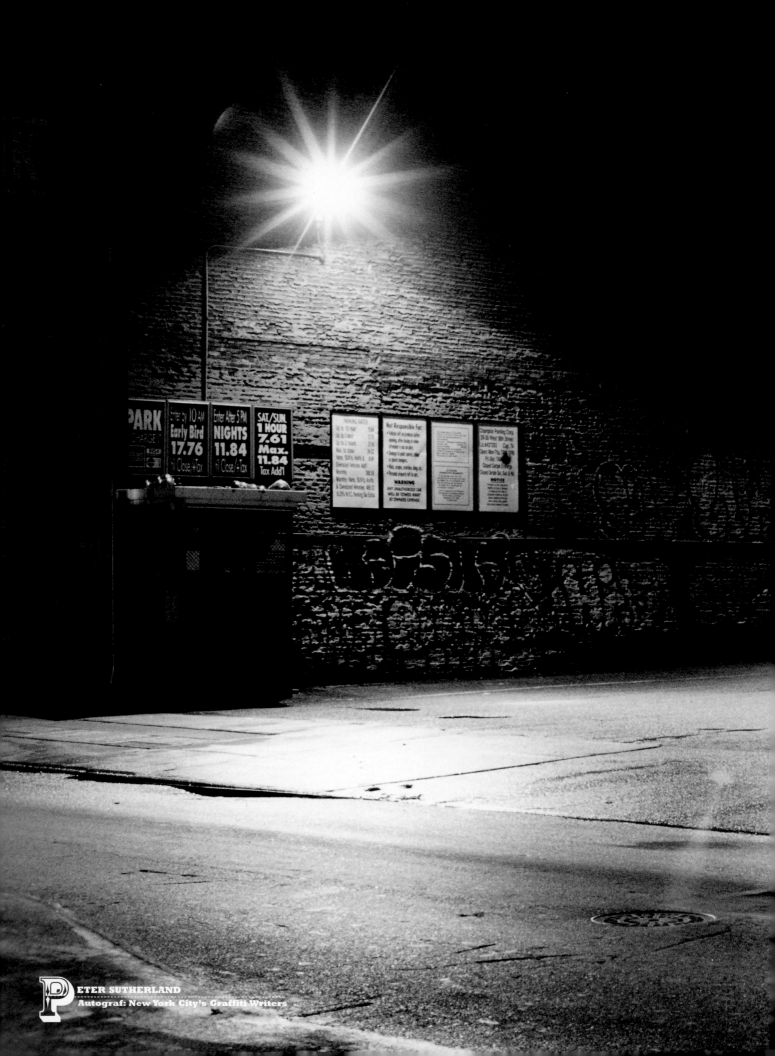

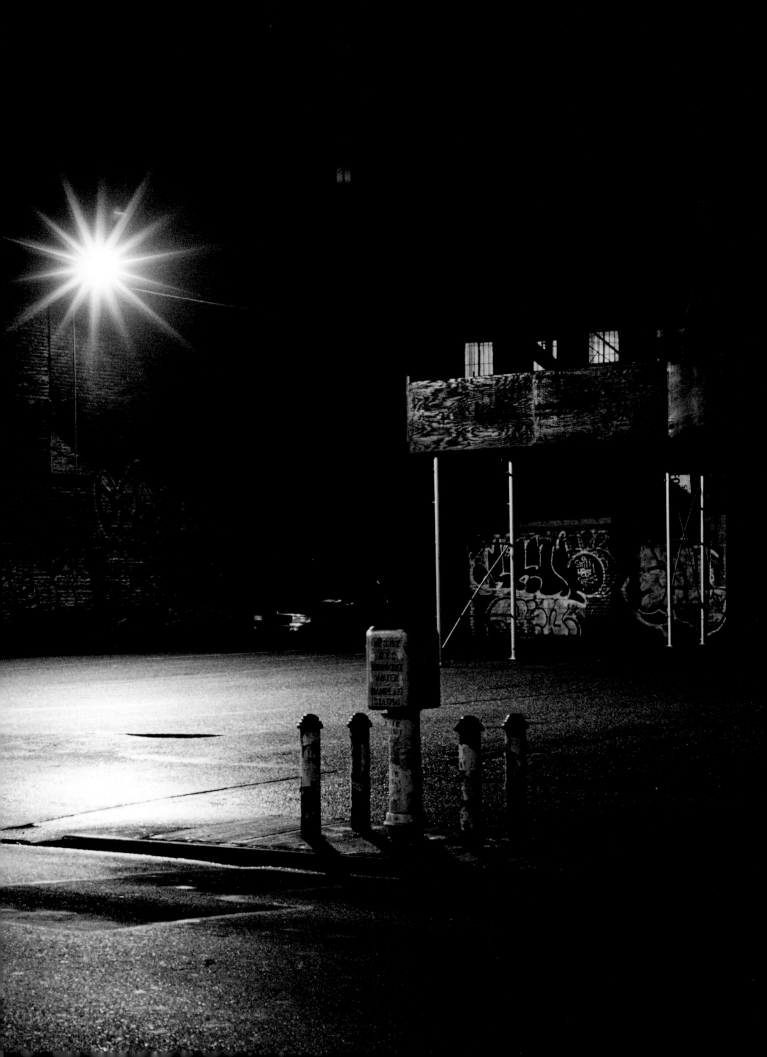

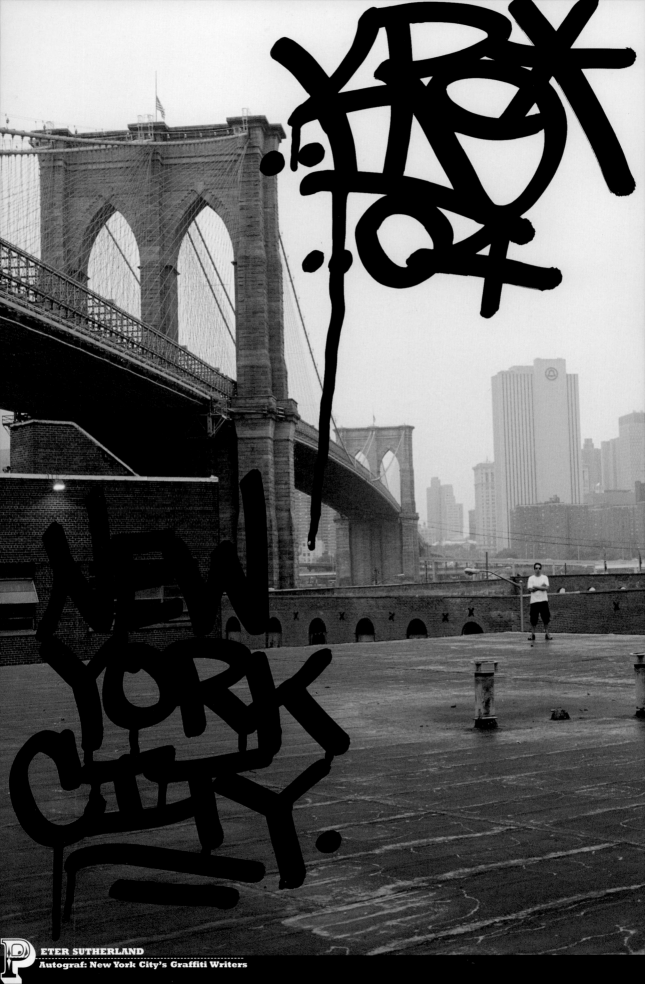

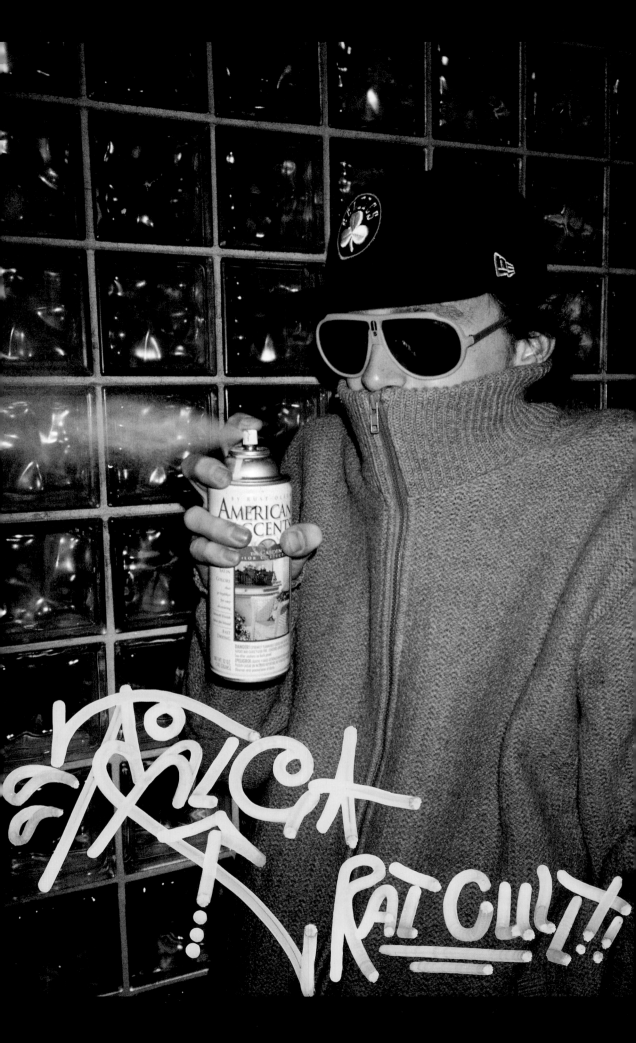

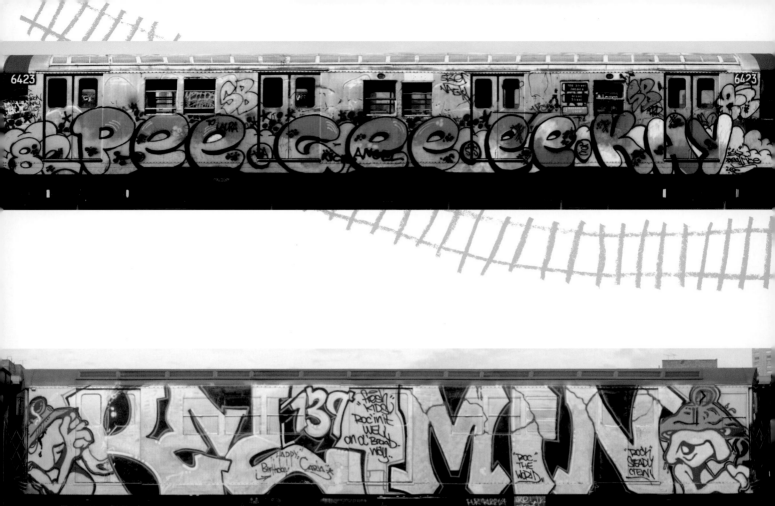

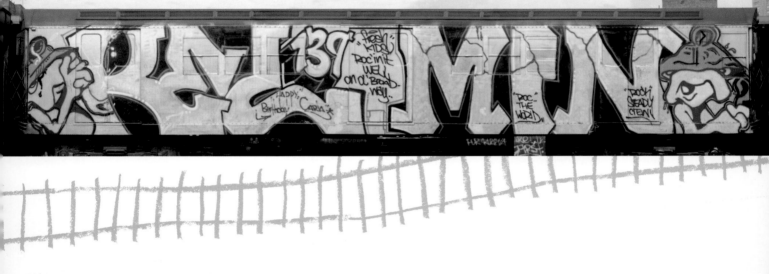

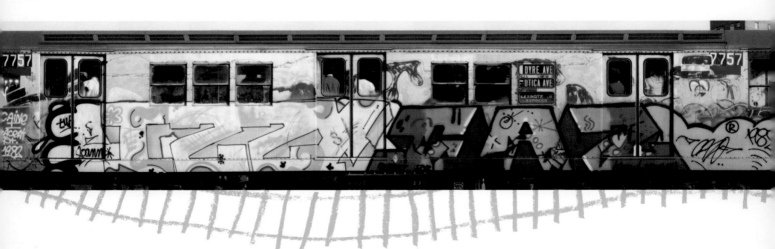

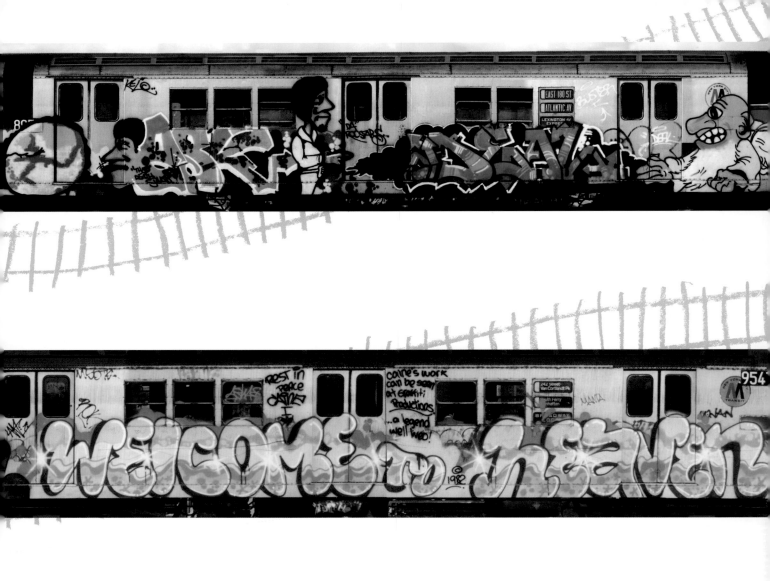

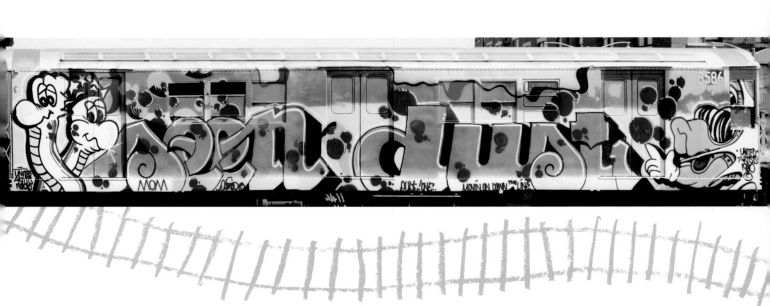

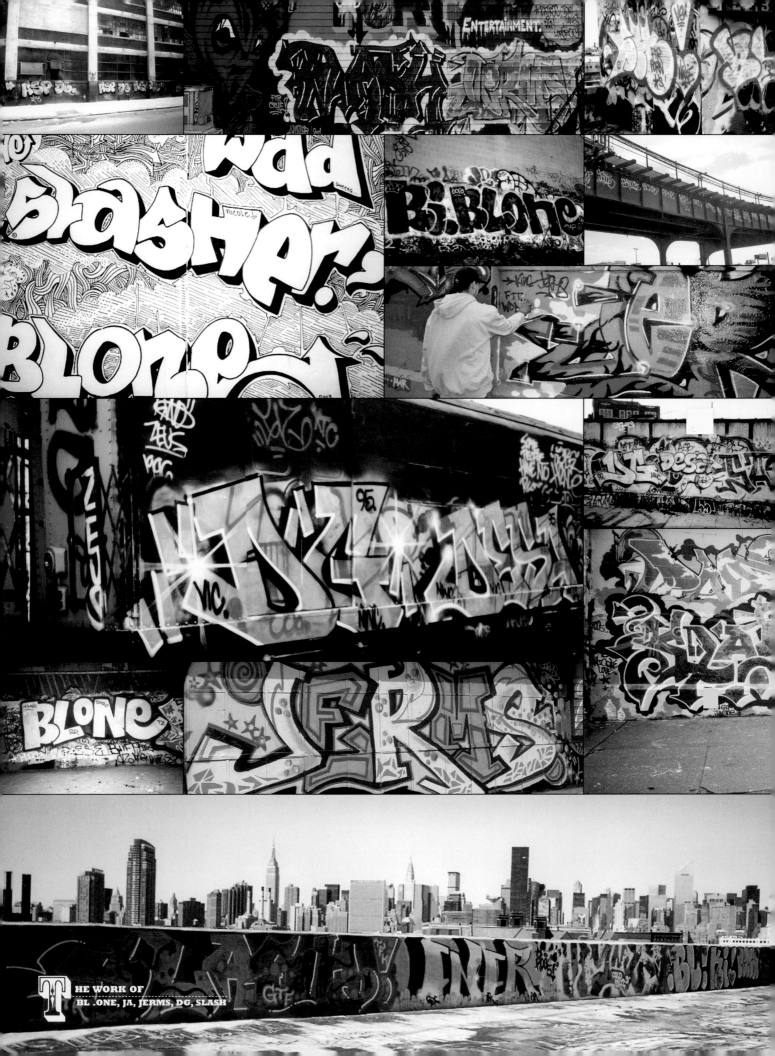

THE WORK OF
BL.ONE, JA, JERMS, DG, SLASH

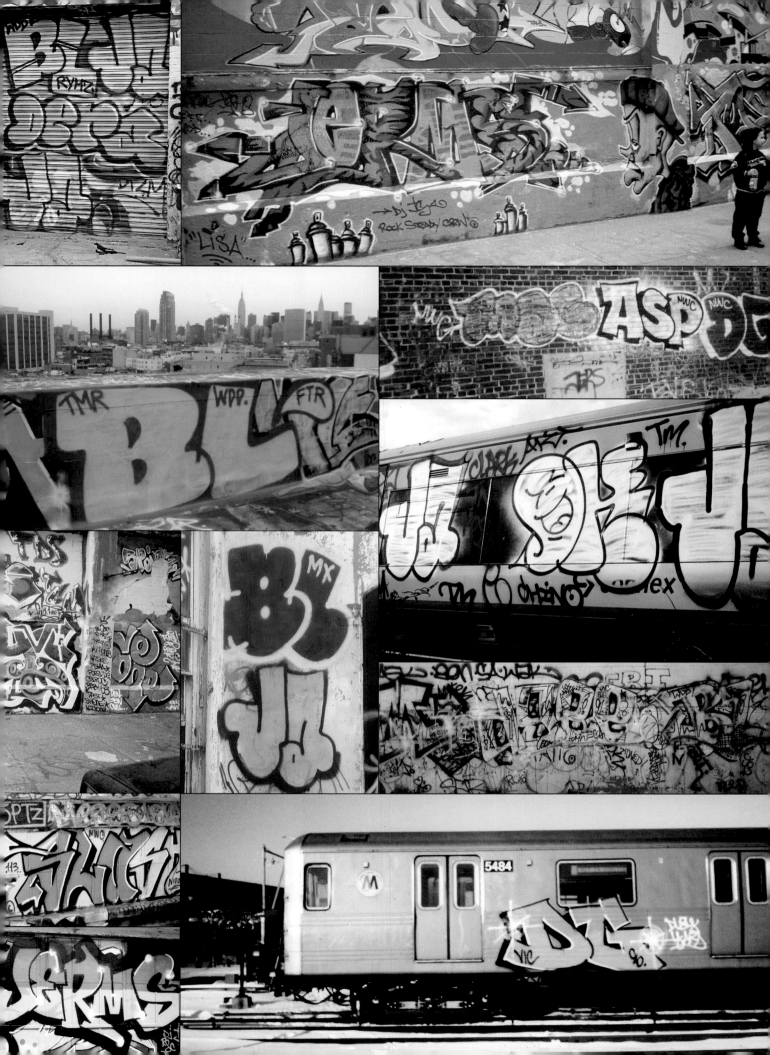

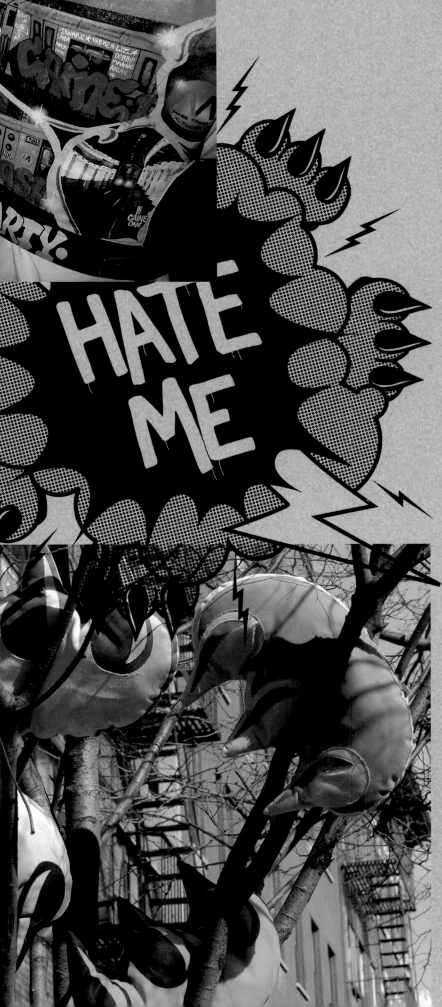

The first time I went to hang out with CLAW, she answered the door to her East Village apartment completely naked. If I wasn't already falling for her, I would've been then. Even with her clothes on, the draw of the CLAW is a Powerfully Magnetic Saccharine that'll have you catching fillings. I met CLAW in 1999, after she had already been retired from street bombing for a minute, but all that would soon change. After a year of my incessant begging, my partner and I were hitting the streets. Before long, she would ensure you saw a CLAW whenever you were walking around downtown. I had always linked up with people strictly for the purpose of painting, so it was super fresh to go out painting with my girl. I have many memories of getting to CLAW's and rousing her for a midnight mission. We had a blast while we were out blasting. Painting with a woman proved to be heavenly; there's something so special and beautiful about it, and there's freedom from the haters saying we must be sleeping together. At the same time, there were new issues I'd never faced as a writer before. I was always painting with boys, and I never took into consideration that this Pair of Matriarchal Sprayers creeping out when only the creeps are out could make a target. Like an older sister, CLAW looked out for me and taught me a lot. One of the jewels she dropped on me was a surefire way to avoid unwanted male attention. We were out painting on a hot summer night. The street was pretty dead except for this crusty ass homeless guy walking towards us. We were hot and he was salivating. "Don't make eye contact," she told me, "he won't say a word." Just as she said this, he passed by muttering in his gravely voice "I'd fuck the both of ya's!" We couldn't stop laughing but I shouldn't have been surprised. Had you ever seen CLAW in a wifebeater you too might be compelled to make similar utterances. One look at the greatest tits in New York and you may be asking yourself: who gives a fuck about fill-ins?!? ▣

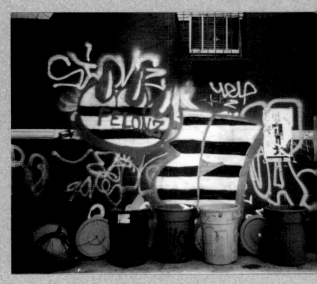

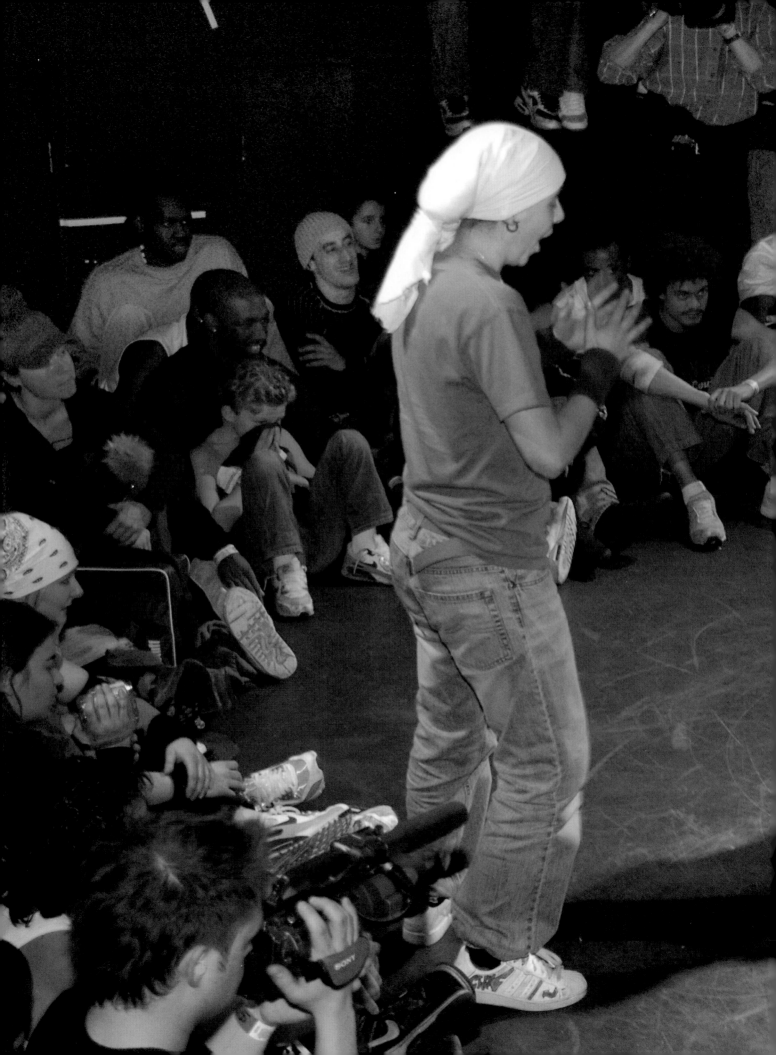

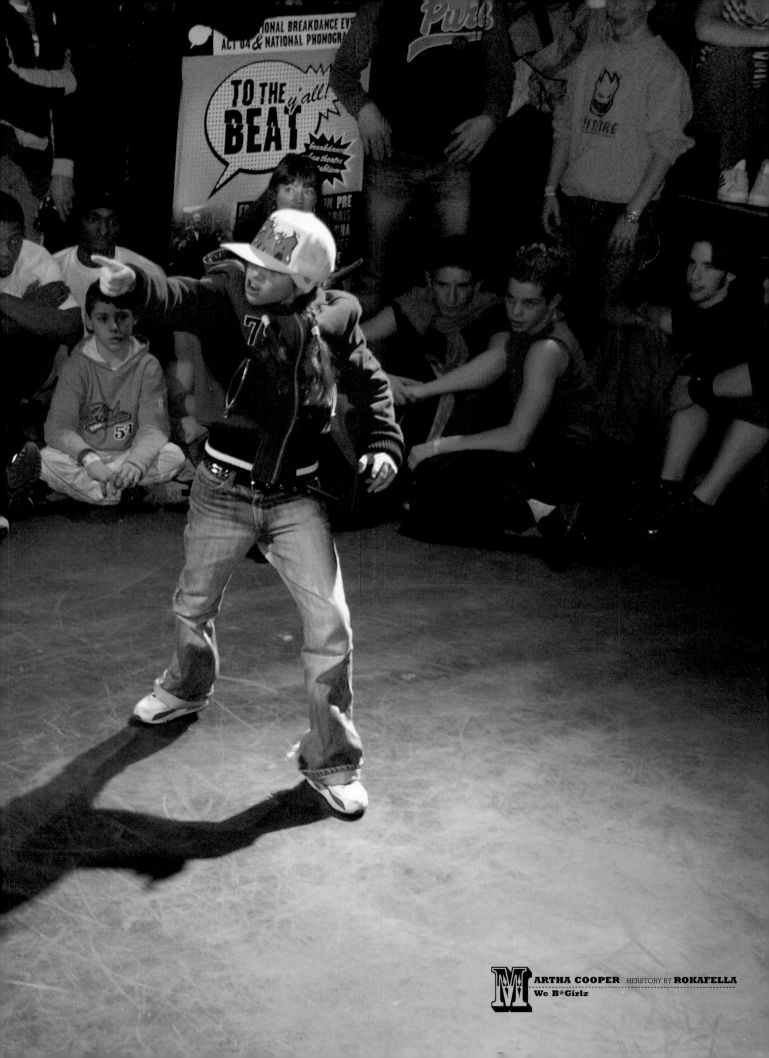

The saying "dancers come a dime a dozen" does not apply to b-girling because the women who enter this realm are self-appointed warriors. To be a b-girl you have mastered (or are mastering cuz I haven't finished my journey) a dance style created in the urban setting. This dance never brought me glamour or material possessions or commercial fame. Rather it is a channel through which aggression, freedom, and confidence are expressed. The movements are asexual and become a testament to the power of the individual holding the floor. Just like the women who do capoeira, I surrender to the music and take my place on that long line of souljahs who embrace the possibility of pain, scrapes, bruises, and the humiliation of a serious injury—the risk of miscalculating a move of falling from grace on your face….Breaking is how I deal with violence, injustice, and impact in my life. What I get in return is personal triumph over my own weakness of character. From the beginning of time there have been women who follow in this same spirit of "I get down too." And from the beginning of time there have been those who feel challenged by a woman's self-determined posture.

I was there watching the circles when breakin' was in full effect. My desire was to jump in, but the extent of my participation was up-rocking on the side and holding jackets for the guys who got down. Hip hop was gonna live forever in my veins. The dance trend changed to simpler party moves and this time the women participated and added their flavor to hip hop moves like the Fila, the Cabbage Patch, the James, Daisy Dukes, Runnin' Man…and I was ready. I was surprised, when Latin freestyle music became the rage, to see exceptional females who commanded attention and danced in the circles. To my dismay, no matter how I excelled at my club steps, some guy would always have to grab me and hump me or humiliate me in the middle of the circle—as if to say "but you can't beat this."

I watched at clubs like Palladium, L'Amour East, The Castle, The Tunnel, and 1018's as they would do it to the other girls who jumped in their territory. I would observe how the girls would not want to enter again. I also noticed this was not how they handled one another—man to man. Among the guys it was either straight respect or straight battle of skills. My boyfriend at the time (RobZen) told me I had to be tough if I was gonna keep jumpin' in the circles. The last time a guy grabbed me and thought he would hump me, I straddled my legs around his waist and then did a back–walk over. I eased out of his grip and slid between his legs. Then I proceeded to mock him by slapping his ass and kicking him out the circle. Robert said I finally made it to the ranks. I realized if I could conquer the floor, the guys would have to wait 'til I was finished or risk getting hurt. They'd have to think twice before tryin' it.

And so began my quest for floor moves, which led me to dancing on the streets with the Transformer/Breeze Team. This is where I met Kwikstep—who invited me into the world of breakin'

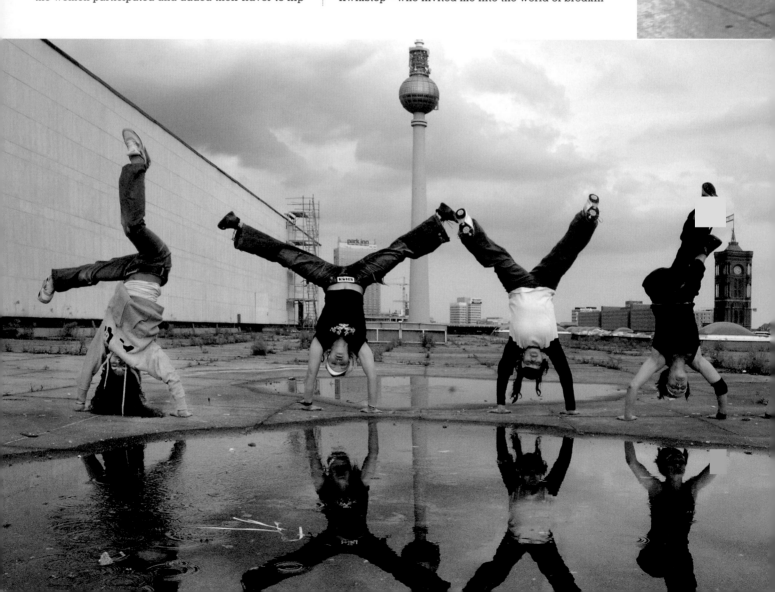

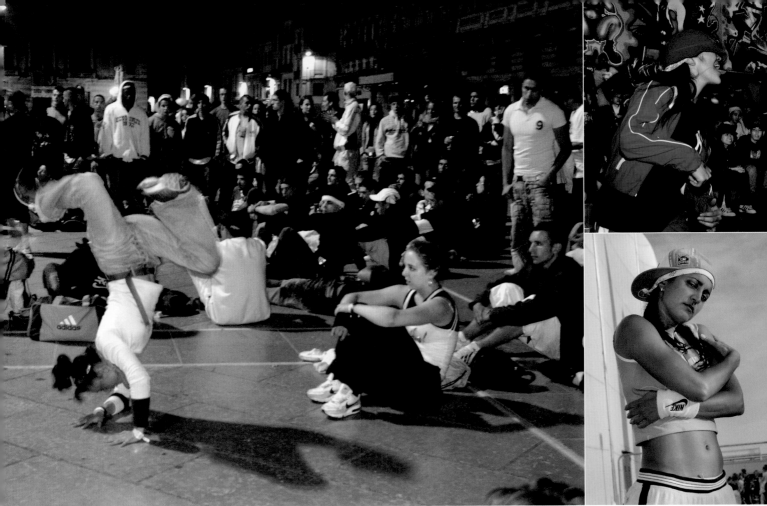

as a serious life-altering journey. At first my basic moves would just aggravate b-boyz who were salivating at the chance to get down to the song. They would make comments like "alright already, you're wasting the song…" and push me out the way. Some would tell me that "breakin' is not for women—it is better to get into popping or locking." As I got better some heads would purposely say I was whack or not as good as the other girls who were doin' other moves. On the street, I had learned not to get caught up in the sex game with none of the other dancers—especially the ones who were cute, popular, or crew leaders. This made me the enemy because I was challenging the status quo and showing other females the alternative reality of self-respect and independence by example. I stood firm in my position even as I watched other girls get fame or money in the hip hop world and I got nothing. I continued teaching, then began directing, and in time I branched out into other artistic realms.

Not all b-boyz were ready to share the glory with a female. Many still don't believe a woman can have the guts, determination, and character to represent the rawest of all dances ever created in the hood. In the streets a woman is good for one thing only. Hip hop comes from the streets. But there have always been exceptions who earn their stripes in the trenches alongside the men. I mentor men and women to break and be streetwise, but I especially urge b-girlz to focus on their training above everything else. In time, if you really pay attention,

ALL the challenges that come with breakin' prepare you for life's challenges. Ultimately the challenge is an internal one.

The music is playing as I approach the circle. Breakers are already dancing, working out their fury in the circle to either a unanimous round of respect or a mediocre response. Even after all this time, 18 years, I can still feel my heart in my throat as I make final mental checks on my gear and shut down the doubts about past injuries or failures. I download all my familiar go-downs and take deep breaths. All that remains is to wait for the right beats—I feel the pull of the circle's energy. I look up and somebody always catches my eyes—they nod and that's when I know I have passed the point of no return. Whether there has or hasn't been any female representation, whether this song is my favorite or not, whether someone will challenge me or not, I surrender and enter the fire, carrying the legacy of the women who came before me…from Johanna Sanguinetti to Lillian Torres to Roxanne Chiang to Peach to Marcella to Aiko Shirakawa, from my hood to my grandmother and beyond…they all reside in my rib cage at that moment. They all surface. They all speak. And when I get up, I can't remember what I did but I know I have just begun another chapter in my dance journal. A journal many men and women have helped to build. My mother and father are included in that list, but especially Kwikstep, who knew I had to "clean up" if I was gonna keep to my mission… █

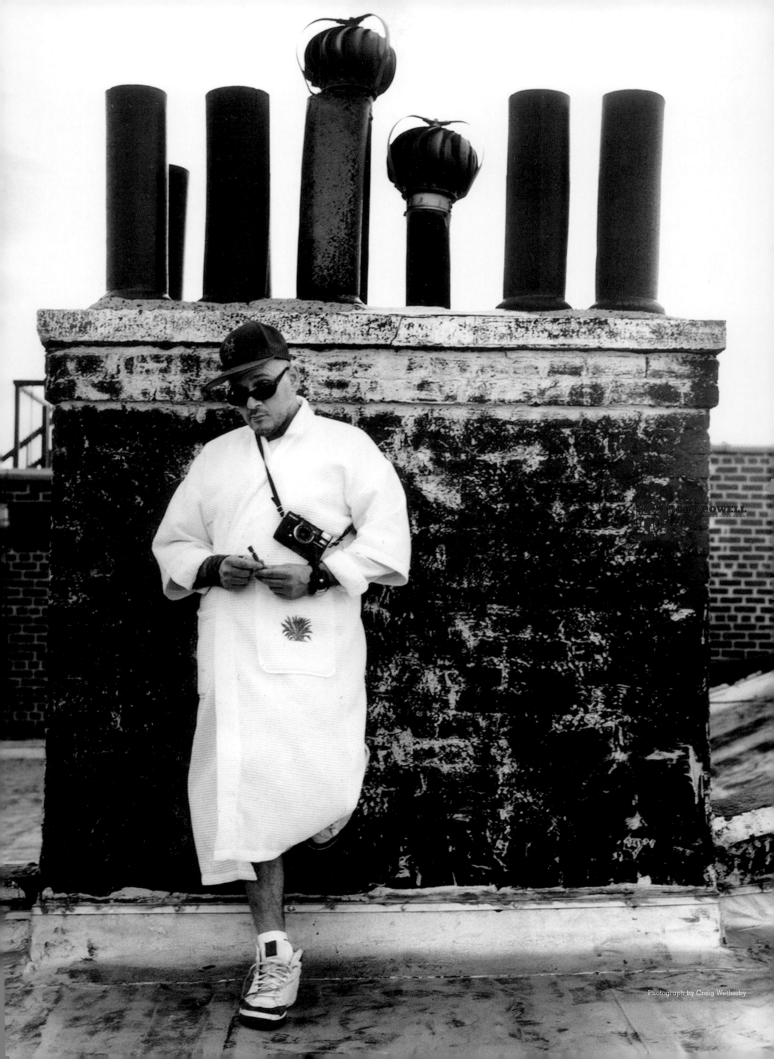

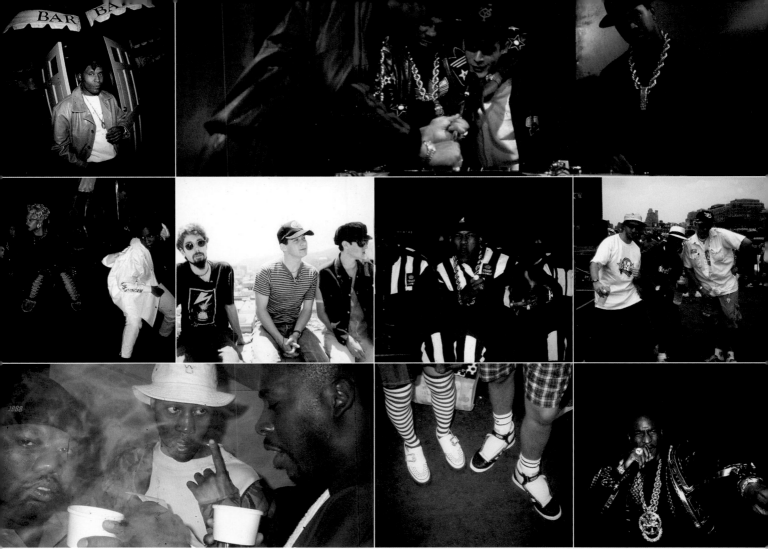

Photographs by Ricky Powell

Hello, how are you? I'm good thank you.

So...? What am I thinking when you ask me about the genre of hip hop...?

Well, I was fortunate to be around when hip hop was taking off in the early- to mid-eighties. I loved it back then, but if you ask me what I think about it today, I might kinda grimace and make a sour face....BUT, I was ridin' with Fab 5 Freddy the other day up 6th Ave and he had just come from seeing Ice Cube and he put his new CD on...and it was BANGIN'....I loved what I heard (a couple of tracks) and it renewed my faith that dope hip hop/rap can still be produced and performed. I also like Ghostface Killa, he's got a cool character and he knows his shit. Oh, and Ludacris...I like him...I saw him on Conan the other night and I was cracking up to the two of them conversating about Ludacris' thing for pretty feet on a girl....Basically it don't matter how fine/cute she is, if her feet are busted, it's off...I was banging my head against the wall with laughter...I could relate, I feel the same way about the subject...It could make/break the deal for me....

But where can you hear good rap if you don't listen to commercial radio or watch (weak) videos...? Because to me "commercial" shit kills it. They (record companies/radio stations/tv stations) pump the worst shit for the most part and it lowers the bar for quality. Where can I hear intelligent hip hop...? That's what I want. Listen, not to be biased but honestly, the Beastie Boys' album *Paul's Boutique* was a feather in the hat of hip hop because of the innovative production by The Dust Brothers and of course Mario Caldato who I love to death (even though I haven't seen him in years) because of the way he thinks....(Oh and also, of course, because of the lyrics and delivery by the Beasties...That's just one example)....I loved NWA in the early 90s as well for similar reasons....Oh shit, sorry, I also liked how Guru and Premiere were on that jaz(zy) tip.

One thing bewilders me though: I wonder why there haven't been too many successful female artists, especially white or Latina....Does an artist have to act like a dim witted street tough to be in the game...? If so, shit is wack....That whole identification is so played out already, wigga please....Look I know hip hop sales are huge thanks to suburban kids who take it (too) seriously but fuck them, don't cater to them (you shallow record execs), think about how the society is going...you want the next generation to be total nimrods?...(I think "boy bands" should be lined up and shot, as well).

Well, listen, like I said before Ice Cube (I've been a big fan of his always) renewed my faith so we'll see I guess how long hip hop will survive... (Hey they thought Doo Wop was gonna be around for a long time too...) Where's KRS-ONE when you need him...Help....
 Stay up, Ricky

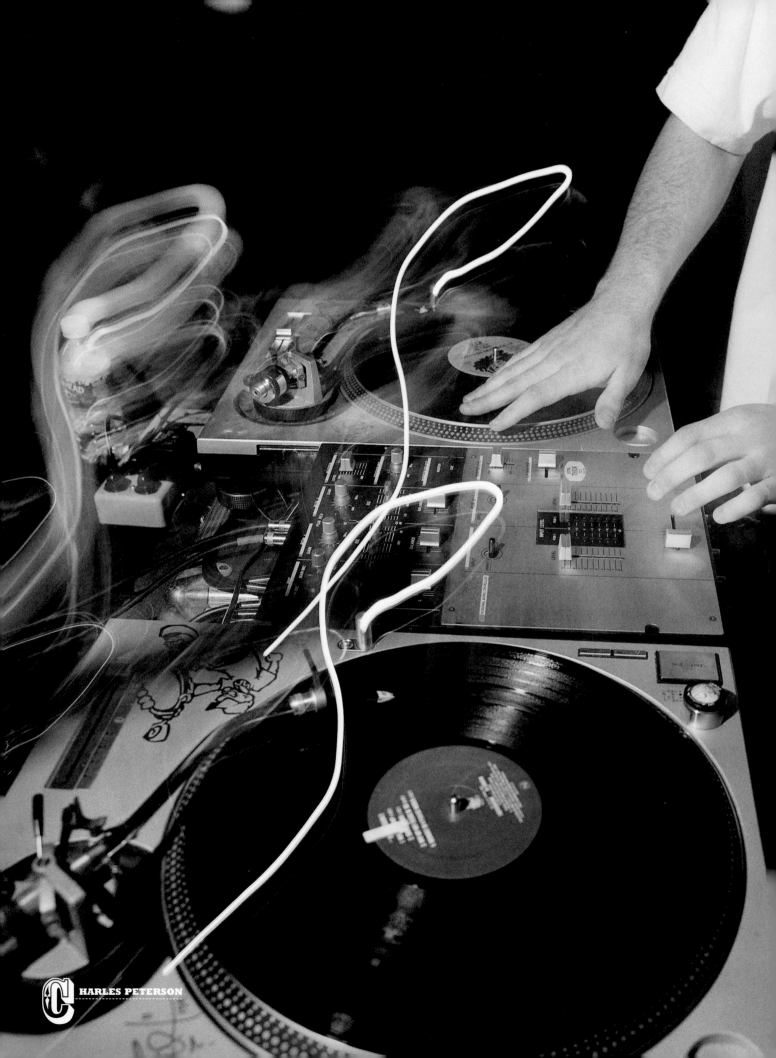

CHARLES PETERSON

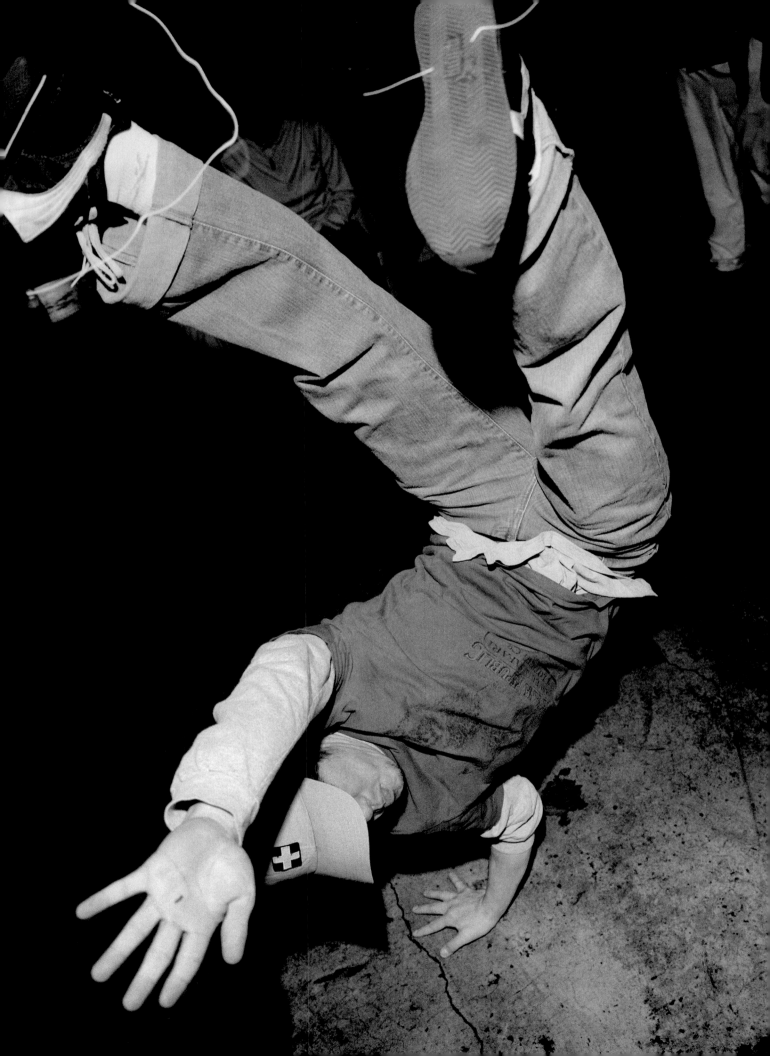

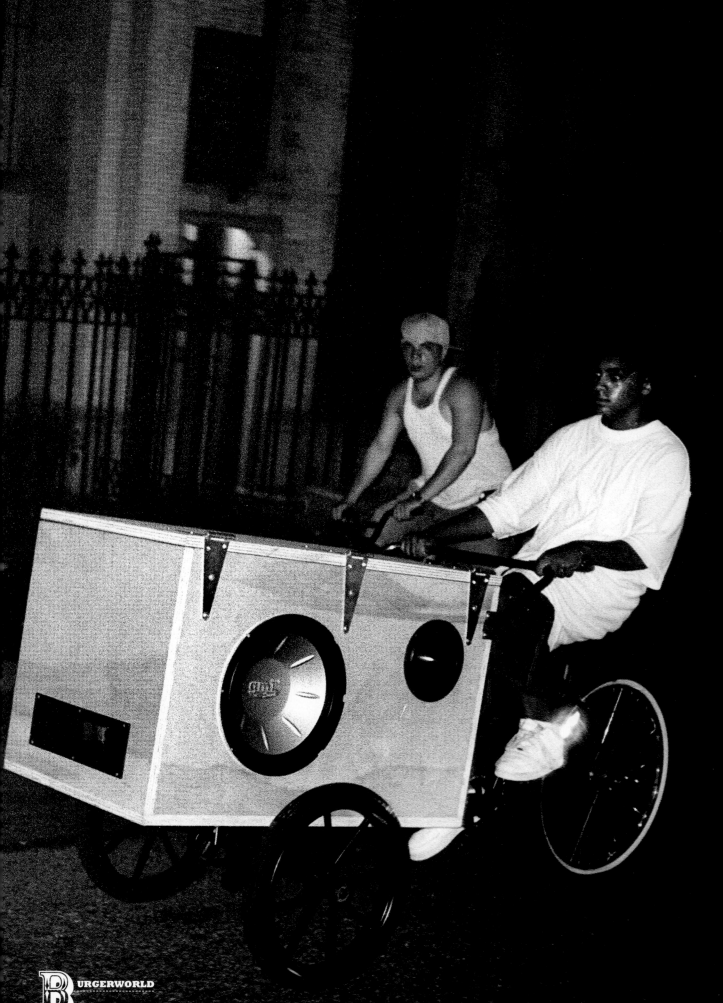

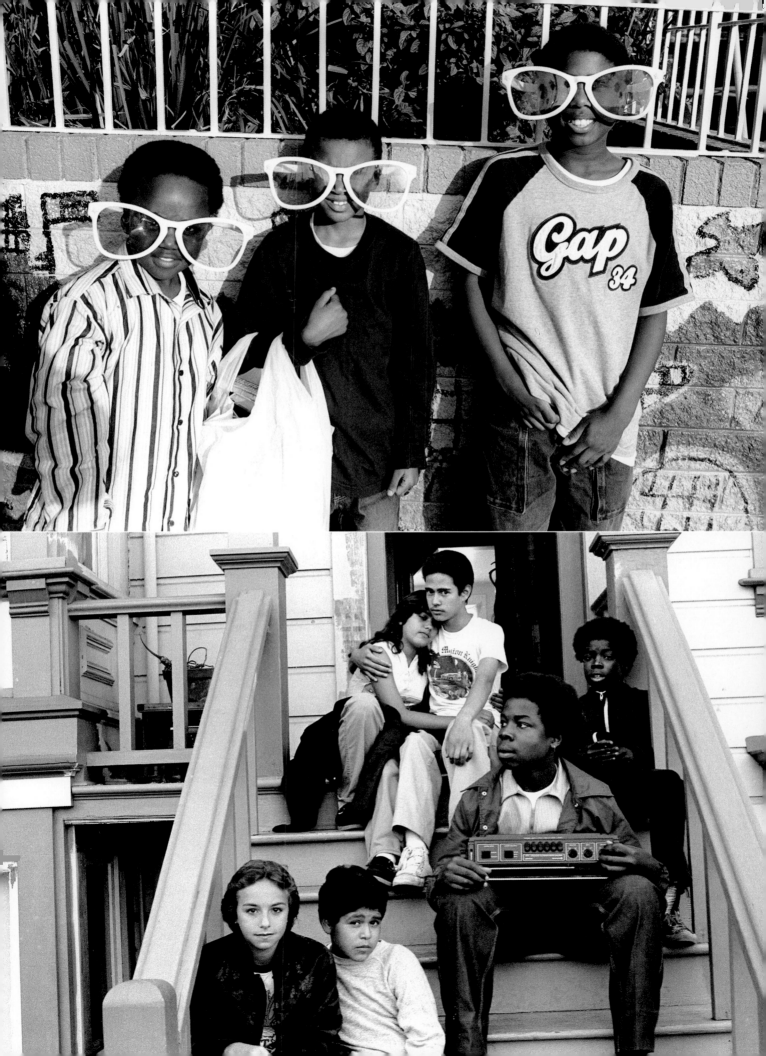

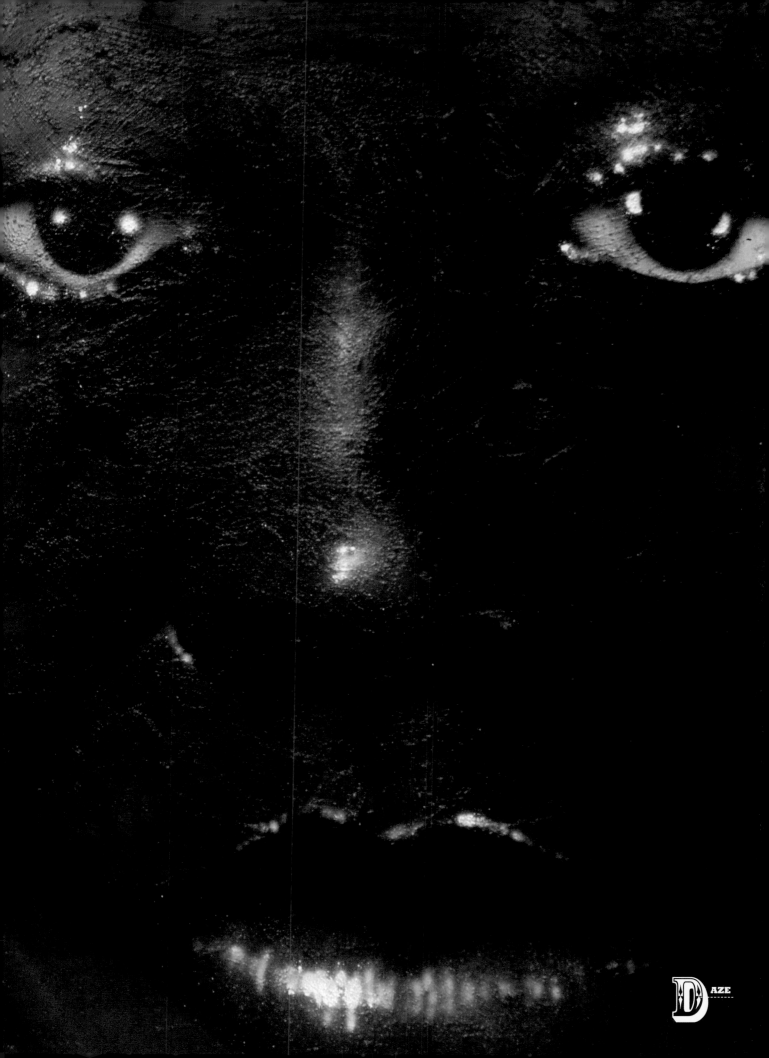

INFAMY: AN INTERVIEW WITH DOUG PRAY

The new documentary by filmmaker Doug Pray, *Infamy*, is an intense journey into the lives, minds, and families of seven graffiti writers—including my girl CLAW—and co-produced by my boy Roger Gastman (of *Swindle*, *While You Were Sleeping*, and the new *Freight Train Graffiti*). They got me tickets for the premiere of the film, which was packed with writers, writers, and more writers. Only thing is, if you've never met them, you'd never recognize them, as they make it a point to be anonymous. Which is what makes *Infamy* so amazing—not only do the writers appear on camera without masks, they get quite personal about their experiences in graffiti. Pray takes us deep into an exclusive world, a world full of some of the most dynamic, hilarious, obsessive, hard-living characters you'll never meet.

Miss Rosen After making iconic documentary films about the most revolutionary subcultures in music in the 90s (*Hype!*, *Scratch*), how did you get interested in the graffiti scene, and what inspired you to try to capture it on film?

Doug Pray It's funny because, while I've always liked looking at graffiti, I never had any impulse to document it as a scene. The subject was brought to me about three years ago, as a straight job opportunity from 1171 Production Group, who repped me for music videos at the time. There was a record company named Paladin who wanted to make a DVD about graffiti, they were fans of my film *Scratch* and would I be interested? At first I said no, but after talking with Roger Gastman, who they foisted upon me as the central project advisor, and after hearing more about the intensity of the typical stories behind graffiti writing—the obsession, the illegality, the lifestyle—I became very interested on a human-

interest level. I guess I had been so previously misinformed by the stereotypes of graffiti that it just didn't interest me as a filmmaker. But once I met these artists and heard what they'd been through to be serious, respected writers—I was completely hooked.

MR How did you hook up with Roger Gastman, and what was his role in the production of the film?
DP Kevin Lewis, the executive producer from Paladin, told me that there was this guy Roger who was going to be the project consultant. From the moment we talked by phone, Roger schooled me. He made it clear just how bad most graffiti films are, how misrepresented graffiti can be, and how amazing the life stories of these artists really are....I was fascinated. Roger's credit in the film became "supervising producer" because, while he wasn't a producer in a typical production way, he worked very closely with me throughout the entire process. Roger came up with the possible artists that we eventually chose to film, he pored over the footage with me and my editor, Lasse Jarvi, to seek the truest moments and to weed out the BS, and because of his connections throughout the graffiti world, he had access to tons of photos. Bottom line is that making a documentary is all about access, and because Roger is widely respected in the graffiti community and has access to A-list writers in every city, he opened all of those doors for me. I couldn't have possibly done the film without him.

MR The writers featured are worthy of films unto themselves. Given their incredible life histories, how did you determine the themes you to explored in the film while keeping the focus tight?
DP It's true—each of these writers could EASILY merit an entire feature film. The first guy I spent a day with was TOOMER, in South Central L.A. Practically everything that came out of his mouth (and the guy never stops talking) was gold. His life story, his current situation, his family, his crew—they

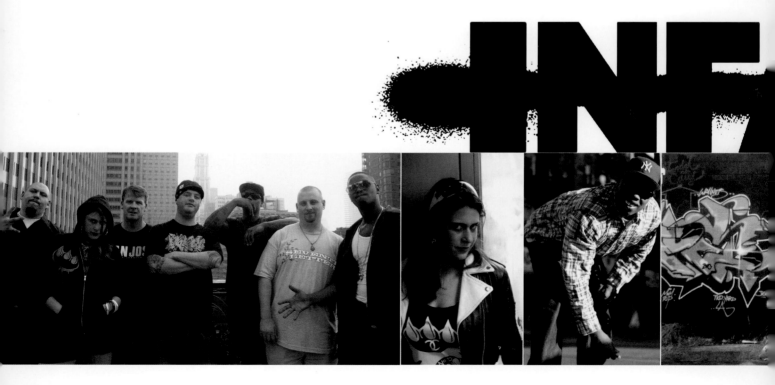

are all worthy. I am glad that I decided to document only a handful of individuals (six writers and a buffer) rather than trying to do an overall portrait of a whole scene or subculture. I've found that paying so much attention to every important historical detail and trying to include everyone important can sometimes be a losing game in films like these, because the more information you add to the film, the less time you have to develop personality and great stories from the individuals. I focused on getting the deepest, most honest, funniest, and truest interviews and scenes with just seven people (CLAW, Joe Connolly, EARSNOT, ENEM, JASE, SABER, and TOOMER). The artists in *Infamy* give so much of themselves, they are so honest and revealing about their identities and lives, that it transcends the usual concerns (what city, what name, what crew, what history). They end up representing all serious graffiti writers, or, if you want to get really cosmic—they end up representing all of us.

MR Joe Connolly represents the long arm of the law, and yet he is a total crackpot. Why did you select him, rather than actual police, to present the other side of the story?

DP Joe Connolly, "the graffiti guerrilla," is 100 percent obsessed with graffiti, obsessed with buffing it out, and as passionate as any writer he's ever covered over. Though I love *Style Wars* I didn't want to have "experts" sitting behind their desks or uniformed cops trying to analyze what makes graffiti tick. Joe is a total rebel—he's been fighting the city of L.A. for years (because he's so publicly outspoken about how lame and ineffective the city's anti-graffiti programs are), he's confrontational, he's proactive, he seeks out graffiti writers and forces meetings with them, he's hated and respected in the same breath. What's interesting is the different crowd reactions we've gotten. In some screenings everyone cheers and loves Joe, in others, he's booed and threatened. Not a lot of fans in his neighborhood! Finally, as for why I didn't

film the police, I wanted the film to take you to places that you'd never go, and introduce you to people you'd never meet— and it seems like we're always hearing from police and city officials on these subjects, so we kind of already know where they're coming from.

MR What preconceptions did you have about graffiti, and how did they change through the making of the film?

DP While there are obviously a lot of brilliant graffiti writers who identify their art with hip hop culture, and see it as one of the elements (especially the trainwriters from back in the day), I was surprised to meet a lot of A-list, life-long graffiti writers who didn't care about hip hop at all: who, even if they loved hip hop as a musical form, were sick of being associated and co-opted by it, as a movement. *Infamy* has nothing to do with hip hop— it's just about graffiti. My other preconceptions were typical of any outsider....I didn't understand how tagging (which the average person hates) connected to the pieces (which the average person likes), but I gained a huge appreciation for their style, what they mean and how to read them. I didn't know much about graffiti crews. I didn't know that lots of the graffiti you see in any large American city in 2006 is by out-of-towners, or kids from the suburbs, or Europeans, etc. And finally, I didn't understand, until making this film, how hard it was for an artist to gain true respect in the graffiti community—that it's not enough to paint an incredible mural on the side of your school. You really have to have been "up" in the streets for years, paid those dues, had run-ins with the law, had your life threatened, had to rack your own paint, get kicked out of the house by your parents, have fights with other writers or gangs or homeless derelicts, inhale lots of aerosol fumes, fall off the side of a building, get thrown in jail—all in the name of supporting your name. I don't think most people realize the drama that's behind most of those tags. I didn't. ◨

THE PUTANO CLAN — ULi → J

CHILLIN IN PUBLIC SCHOOL

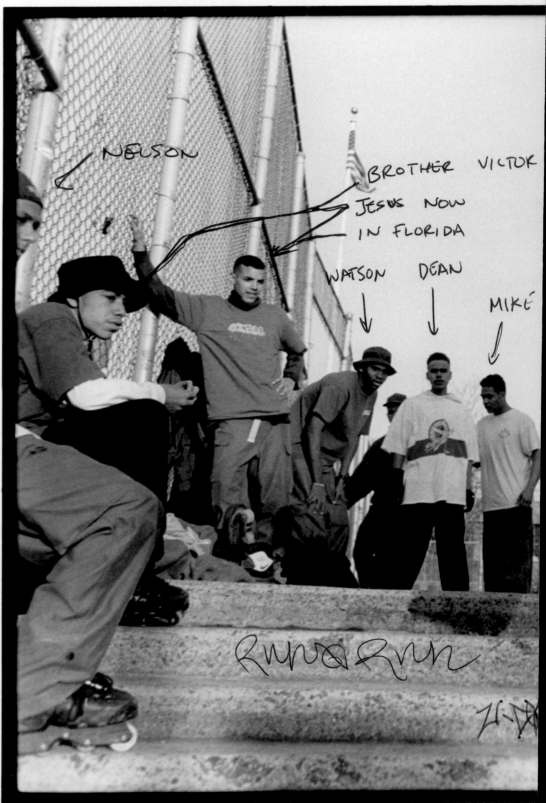

NELSON

BROTHER VICTOR

JESUS NOW
IN FLORIDA

WATSON DEAN

MIKÉ

EDDIE VELASQUEZ "RICH"

MICHEAL RUIZ DOING A BACK SLIDE IN 84

THIS IS MY FAVORITE BECAUSE AS YOU CA

I LIKED TO SESSION EVERY WHERE TO

AND RICH

34 BROOKLYN NY

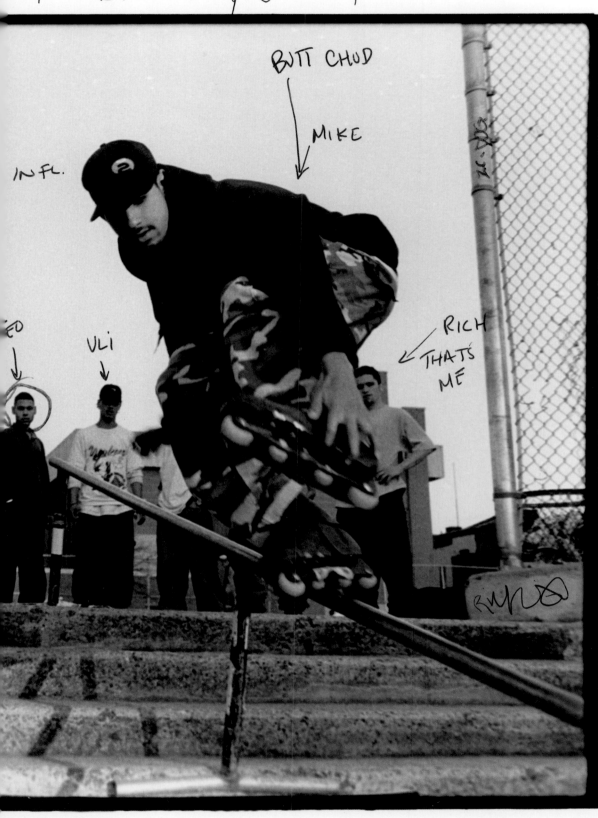

BUTT CHUD
MIKE

INFL.

VLI

RICH
THAT'S
ME

From Richie Rich Jes Fuckin Rocks

SEE EVERYONE IS HERE. THIS IS THE WAY

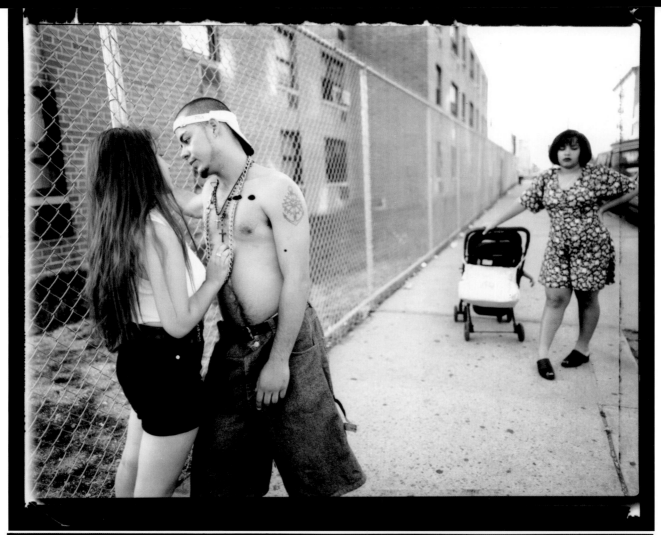

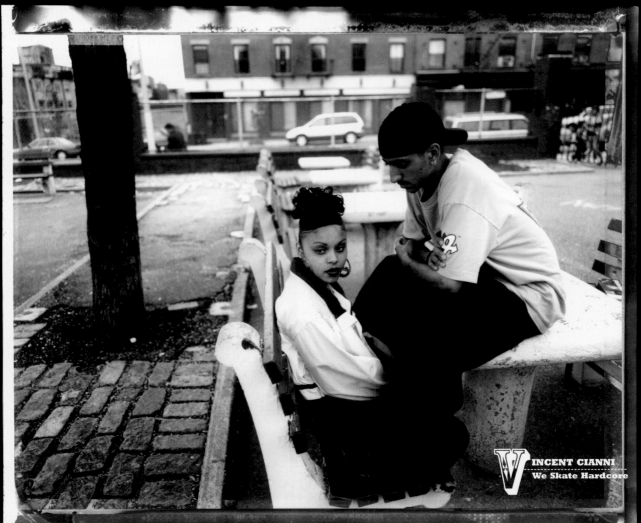

JOSEPH RODRÍGUEZ
East Side Stories: Gang Life in East L.A.

July 4, 1992
When I arrived in South Central, the remains of the riot still lay everywhere, even though it had been cleaned up for some. Expecting to find violence, I found a truce between the Crips and the Bloods—families coming together after years of shooting at each other over colors. However at the other end of town, in East L.A., the truce was nonexistent among Chicano gangs. Ten days after I arrived, I photographed a five-year-old boy and his grandmother who had been hit by AK-47 fire through their living room wall, and a two-year-old who was killed because a family member wanted to leave his gang. This was difficult for me, having two four-year-old girls at the time myself. Life seemed cheap. Many of the gang members I spoke with felt they had been forgotten, no different than the Watts riots of 65. Forgotten promises.

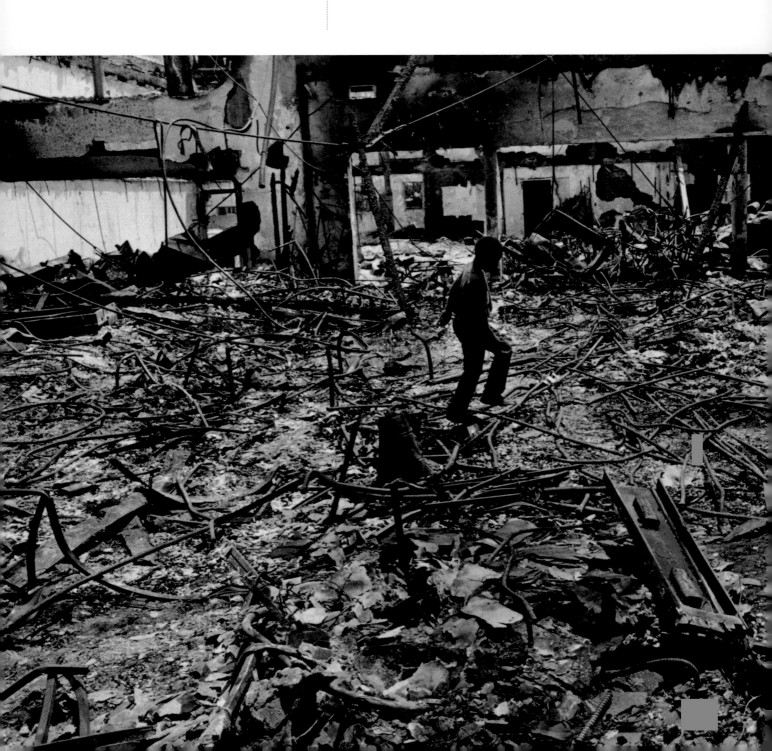

July 4, 1992
Gangs seem to start as unstructured groups of children who desire the same as any young group: respect, a sense of belonging, protection. In a lot of ways, it's not different than the Boy Scouts.

May 30, 1992
Jacques Eldridge, seventeen years old, is the son of Roth, an OG (original gangster) from the Bloods. He says, "Bloods and Crips give kids something to identify with, to belong to a pack. It's a substitution for what our people should be giving them, what the family and society should be giving them. I would feel guilty if I brought a child into the world; there's some serious things in this neighborhood."

I asked him what the gang meant to him: "It's about self-confidence. A gang is a banding together of what you feel is your own kind. I think about it like my family. I'm not going to kill for some address or zip code, I'm going to kill for a cause."

May 29, 1992
In Watts, choppers pass overhead, acting as back-up for cops whenever a serious crime goes down. Bobby is introducing me to the East Side Bishops, telling me to be cool. "Don't get to friendly with them; sometimes a few of the guys are hardcore—2 or 3 percent." They could get smoking the wrong shit, then all of a sudden I'm the wrong guy, I'm outside and could get hurt. I didn't really think about the danger. You don't know how close you can actually get with them. His homies said that I could be black, "Yo! He's from New York." "Hol' up," Bobby says, pulling my coat, "these guys could shoot in a minute." The choppers pass overhead, and I get a Vietnam kind of feeling. ◨

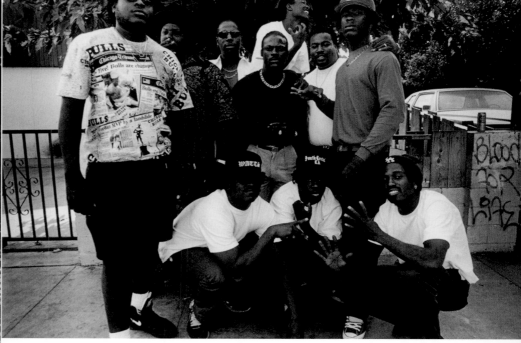

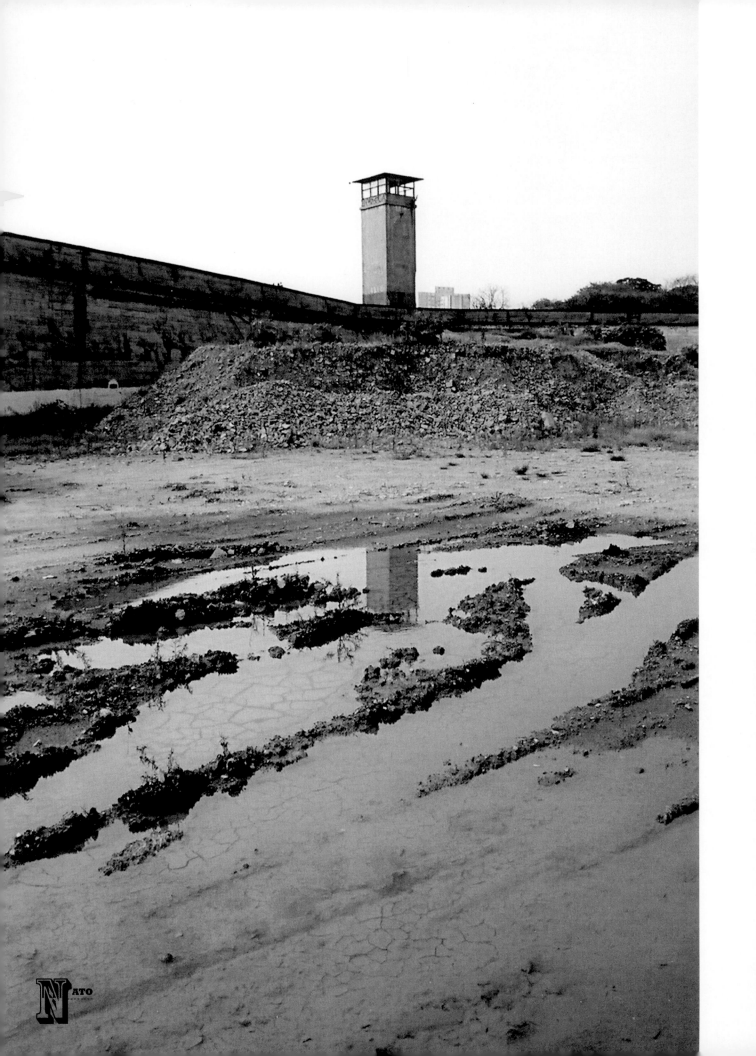

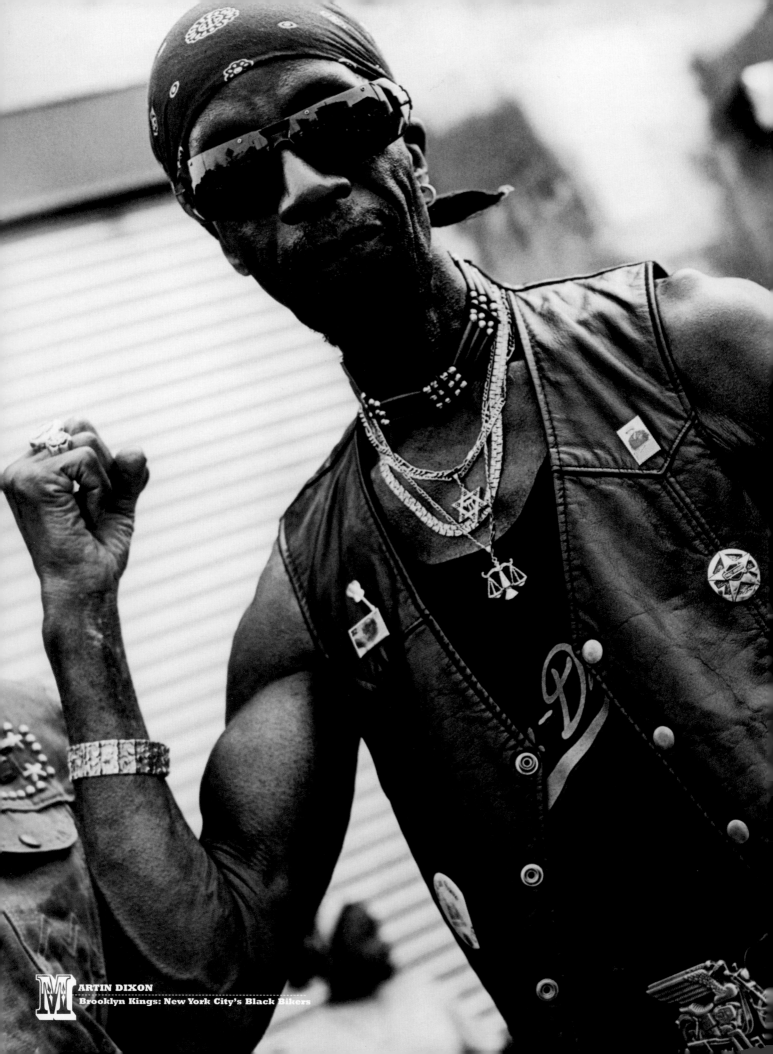

Cover. Tattoo convention, Coney Island, Brooklyn, NY, 1998, photograph © Boogie.

P.10. JASMIJN, silkscreen and oil paint marker on subway map, artwork © QUIK

P.12. Buckwild Mixtapes, The Boogie Down Bronx, NY, 1994, photograph © Delphine Fawundu-Buford

P.14. Photograph © David Yellen

P.16. Salted pig tails, Brooklyn, NY, 1998, photograph © Delphine Fawundu-Buford

P.18. Photograph © Jamel Shabazz

P.20. Tracks at the Brighton Beach D train station, Brooklyn, NY, 1986, photograph © Ricky Powell

P.22. The Cadets at a meeting in their clubhouse in an abandoned building. They made their guns from sticks of wood, clothespins, rubber bands, and tape, Alphabet City, NY, c. 1978, photograph © Martha Cooper

P.23. Jumping from the fire escape onto mattresses provides a quick exit from a secret clubhouse in an abandoned building, Alphabet City, NY, c. 1978, photograph © Martha Cooper

P.24. "Hitchiking" buses was a favorite form of adventure play in the late 70s, photograph © Martha Cooper

P.26. Photograph © Helen Levitt

P.27. Photograph © Helen Levitt

P.28. Top: Brooklyn, NY, 1979, photograph © Jamel Shabazz; photograph © Jamel Shabazz

P.29. New York, NY, 1981, photograph © Jamel Shabazz; photograph © Jamel Shabazz

P.30. Abandoned school, Bronx, New York, 1979, photograph © Lisa Kahane

P.32. Basketball players, New York, 1990, photograph © Janette Beckman

P.33. Double Destiny, New York, 1989, photograph © Janette Beckman

P.34. Patti Astor standing in the door of her Fun Gallery during a Futura show c. 1981, photograph © Martha Cooper

P.36. From the publicity shoot for They Said It Couldn't Be Done, 174th Street and Boston Road, Bronx, NY, 1986, photograph © Carol Friedman

P.38. Busy Bee, Clark Kent on the turntables (Kool Herc's DJ), Richie T behind, T-Connection, Bronx, 1980, photograph © Charlie Ahearn

P.40. RUN-DMC, New York, 1988, photograph © Ricky Powell, artwork © DR.REVOLT, 2001

P.42. Photographs © Thomas Roma

P.44. Projects, Bedford-Stuyvesant, NY, 2003, photograph © Boogie

P.45. Projects, Bedford-Stuyvesant, NY, 2005, photograph © Boogie

P.46. Dope E of the Terrorists out of his bedroom window, 3rd Ward, Houston, TX, 2005, photograph © Peter Beste

P.47. Top: Guns and syrup at Z-RO's House, Houston, TX, 2005; Bottom: ESG, Mixing syrup, Houston, TX, 2005, photographs © Peter Beste

P.48. Big Pun, LOUD Records office, New York, late 90s, photograph © Chris Neiratko, text originally published in Big Brother

P.50. Under the table with Snoop Dogg, photograph © Mark Peterson

P.52. Just after the acquittal on murder charges of a defendant in the racial killing of 16-year-old Yusuf K. Hawkins, the protest turns radical with the carrying of Yusuf's mock coffin, Brooklyn, New York, May 1990, photograph © Q. Sakamaki

P.54. Prince Ken Swift, polished stainless steel, 2003, by Carlos "MARE 139" Rodriguez, photograph © Nathan Sherman

P.56. Photographs © Jamel Shabazz

P.58. Hip hop ladies, Brooklyn, NY, 1995, photograph © Delphine Fawundu-Buford

P.60. Brick Lady Crying, artwork © LADY PINK

P.61. Surrender, acrylic on canvas, 2006, artwork © TOOFLY;

photograph courtesy Lisa Kahane

P.62. Parking lot, Chinatown, NY, 2003, photograph © Peter Sutherland

P.64. KR, Brooklyn, NY, 2001, photograph © Peter Sutherland

P.65. RATE, New York, NY, 2002, photograph © Peter Sutherland

P.66. Top to bottom: PEE GEE KAY on the J Train, 1982, photograph © Henry Chalfant; KEL MIN on the 2 and 5 lines, 1983, photograph © Henry Chalfant; IZZY CAZ on the 5 line: Peace at Last for Caine I, 1982, photograph © Henry Chalfant

P.67. Top to bottom: Welcome to Heaven by LADY PINK on the 1 line, painted in the Ghost Yard, 1982, photograph © Henry Chalfant; ASK DEAL on the 5 line, 1980, photograph © Henry Chalfant; SEEN DUST on the 6 line, 1980, photograph ©Henry Chalfant

P.68. Photographs © BL .ONE, DG, JA, JERMS, and SLASH

P.70. Photographs © Claw Money

P.72. Wonder Woman Fatima, 12, from France, challenging Célia from Switzerland at IBE, Rotterdam, Netherlands, 2004, photograph © Martha Cooper

P.74. Female Artistics on the roof of Palast der Republic, Berlin, 2004, photograph © Martha Cooper

P.75. Clockwise from top right: Emiko of Flexible Flave performing at Opaline, NY, photograph © Martha Cooper; SunSun, Montpellier, France, photograph © Martha Cooper; Crowded square with girl upside-down on hands: B-Girlz Emilie and Betty practicing on the plaza in Montpellier, France after BOTY, 2005, photograph © Martha Cooper

P.76. Ricky Powell, New York, NY, 2005, photograph © Craig Wetherby

P.77. Photographs © Ricky Powell

P.78. DJ Scene, Vera Project, Seattle, 2002, photograph © Charles Peterson

P.79. Nation, Seattle, 2001, photograph © Charles Peterson

P.80. Lower East Side, NY, 2005, photograph © Stefan Simikich, courtesy Hamburger Eyes

P.81. Top: Stunncz, 24th and Mission, San Francisco, CA, 2005, photograph © Ray Potes, courtesy Hamburger Eyes; Bottom: Photograph © Ted Pushinsky, courtesy Hamburger Eyes

P.82. Money clip by KEL 1ST, photograph © William Alicia for Stegographica.com

P.83. Mahogany, spray paint, and pumice on canvas, 2000, artwork © DAZE

P.84. Photographs courtesy Doug Pray

P.86. The Pu-Tang Clan, P.S. 84, Grand Street, Williamsburg, Brooklyn, 1997, photograph © Vincent Cianni

P.88. Evergreen Park, Boyle Heights, Los Angeles, CA, 1992, photograph © Joseph Rodríguez

P.89. Top: Anthony hitting on Giselle, Vivien waiting, Lorimer Street, Williamsburg, Brooklyn, 1996, photograph © Vincent Cianni; Bottom: Monica and Eddie, P.S. 84, Grand Street, Williamsburg, Brooklyn, 1997, photograph © Vincent Cianni

P.90. Post-riot South Central, Los Angeles, CA, 1992, photograph © Joseph Rodríguez

P.91. Members of Eastside Bishops, Los Angeles, CA, 1992, photograph © Joseph Rodriguez

P.92. Abandoned guard tower, Carendiru Jail, Sao Paulo, Brazil, 2005, photograph © NATO

P.93. Bushwick off my fire escape, Brooklyn, 2002, photograph © NATO

P.94. Cool Breeze of the Untouchables at the Imperials' Bike Blessing, Brooklyn, NY, photograph © Martin Dixon

P.104. Donnie at the Speedway, Philadelphia, PA, photograph © Martha Camarillo

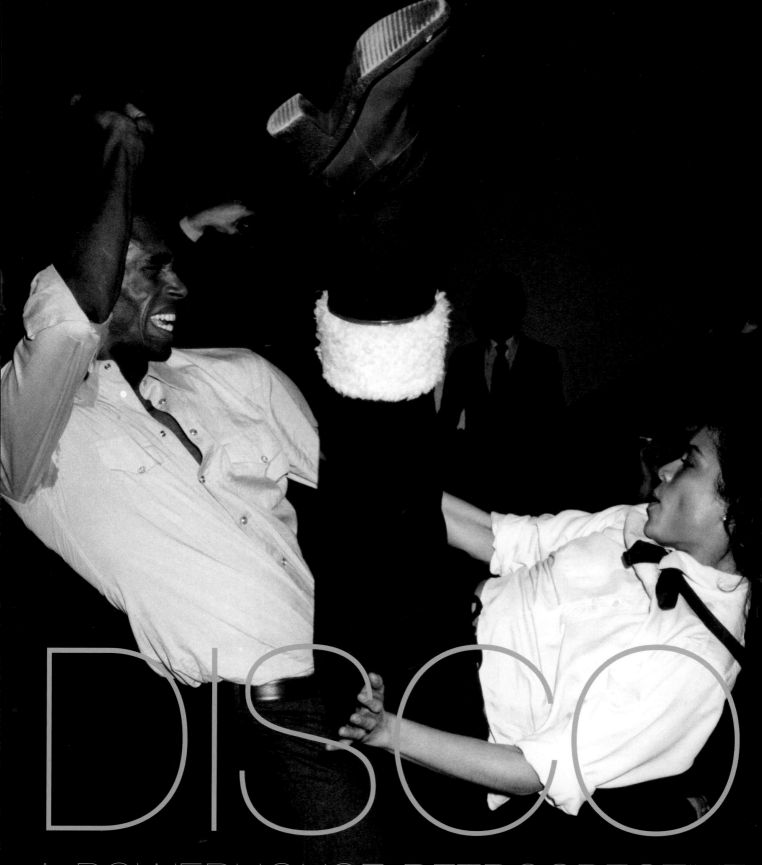

DISCO

A POWERHOUSE RETROSPECTIVE

Get down on it! Featuring works by Ron Galella, Larry Fink, Patrick McMullan, Christopher Makos, Bob Colacello, Jill Freedman, Maripol, Arlene Gottfried, Bob Adelman, and even Joseph Rodriguez. **Disco Years** is the definitive visual diary of the New York club scene in the 70s and 80s, spotlighting an astounding collection of photographs from America's premier nightlife photographers and one cab driver. Their candid shots of the era's fabulous fashionistas, indulgent rock idols, outlandish artists, mystical muses, jet-setting socialites, and fantastic freaks reveal the delicious decadence that defined the decade. The show will be enhanced by a selection of rare photographs documenting revelers alongside shots taken after hours in the Meatpacking District when it was the epicenter of all things debaucherous. Opening November 29 and running through January 6, 2007, **powerHouseArena** is planning a series of events to celebrate good times—yea yea—including a VIP panel discussion, and book signing party with Ron Galella. Shake your groove thing on www.powerHouseArena.com/DiscoYears.

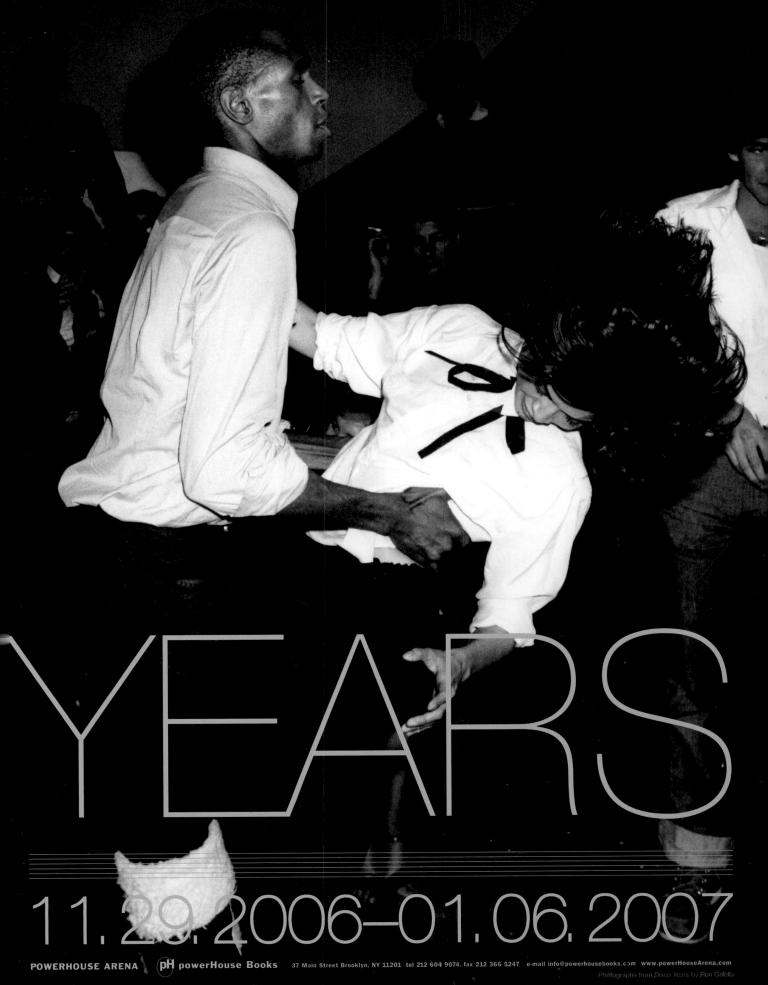

YEARS

11.29.2006—01.06.2007

POWERHOUSE ARENA pH powerHouse Books 37 Main Street Brooklyn, NY 11201 tel 212 604 9074, fax 212 366 5247 e-mail info@powerhousebooks.com www.powerHouseArena.com

Photographs from *Disco Years* by Ron Galella

CURATED BY

CHRISTOPHER MAKOS

IT'S BEEN A LONG TIME...

POWERHOUSE ARENA pH powerHouse Books 37 Main Street Brooklyn, NY 11201 tel 212 604 9074, fax 212 366 5247
e-mail info@powerhousebooks.com www.powerHouseArena.com